Paint Amazing Watercolors From Photographs

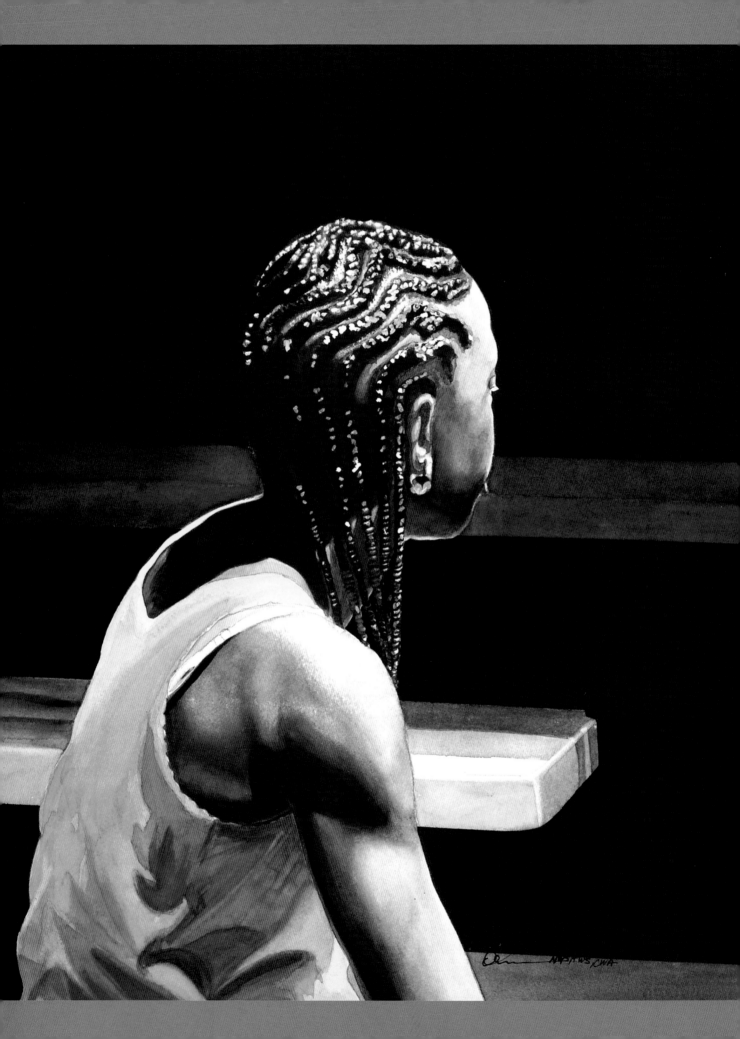

paint
AMAZING WATERCOLORS
from photographs

HENRY W. DIXON

NORTH LIGHT BOOKS
CINCINNATI, OHIO
www.artistsnetwork.com

Paint Amazing Watercolors From Photographs. Copyright © 2009 by Henry Dixon. Manufactured in China. All rights reserved. No part of this book may be reproduced in any form or by any electronic or mechanical means including information storage and retrieval systems without permission in writing from the publisher, except by a reviewer who may quote brief passages in a review. Published by North Light Books, an imprint of F+W Media, Inc., 4700 East Galbraith Road, Cincinnati, Ohio, 45236. (800) 289-0963. First Edition.

Other fine North Light Books are available from your local bookstore, art supply store or visit our website at www.fwmedia.com.

13 12 11 10 09 5 4 3 2 1

DISTRIBUTED IN CANADA BY FRASER DIRECT
100 Armstrong Avenue
Georgetown, ON, Canada L7G 5S4
Tel: (905) 877-4411

DISTRIBUTED IN THE U.K. AND EUROPE BY DAVID & CHARLES
Brunel House, Newton Abbot, Devon, TQ12 4PU, England
Tel: (+44) 1626 323200, Fax: (+44) 1626 323319
Email: postmaster@davidandcharles.co.uk

DISTRIBUTED IN AUSTRALIA BY CAPRICORN LINK
P.O. Box 704, S. Windsor NSW, 2756 Australia
Tel: (02) 4577-3555

Library of Congress Cataloging in Publication Data
Dixon, Henry (Henry W.)
Paint amazing watercolors from photographs / Henry Dixon. -- 1st ed.
p. cm.
Includes index.
ISBN 978-1-60061-125-4 (hardcover : alk. paper)
1. Watercolor painting--Technique. 2. Painting from photographs--Technique. I. Title.
ND2422.D59 2009
751.42'2--dc22 2008044029

Edited by Jeffrey Blocksidge, Mary Burzlaff and Jennifer Lepore Brune
Designed by Wendy Dunning
Production coordinated by Matthew Wagner

Art on page 2: YELLOW TANK TOP
watercolor on 300-lb. (640gsm) cold-pressed paper
19" × 16" (48cm × 41cm)

ABOUT THE AUTHOR

Henry W. Dixon attended Western Michigan University in Kalamazoo, Michigan, where he studied Graphic Design under renowned designer Jon M. Henderson. While working on an assembly line for the Bendix Corporation, Dixon decided that was not going to be his life's career. He decided to return to college. With a wife and two sons, he managed to acquire his B.A. and M.A. degrees.

After completing college, he used his creative skills and talents at Hallmark Cards in their design department, but his love was always painting with watercolor. Dixon is a signature member of the National Watercolor Society, Texas Watercolor Society, California Watercolor Association, Watercolor West, Kansas Watercolor Society and an associate member of the American Watercolor Society.

His work is in many private collections and corporate collections, such as Sprint, Hallmark Cards and Kaiser Permanente, to name a few. His work is also included in the permanent collections of the White House Museum and the Nerman Museum of Contemporary Art, and has been featured in many magazines such as *American Artist*, *The Artist's Magazine*, *International Artist Magazine* and others, as well as books including *Splash 5: Best of Watercolor* and others.

Dixon's painting philosophy is to listen to that small quiet voice that tells him "the painting is done."

Metric Conversion Chart

To convert	to	multiply by
Inches	Centimeters	2.54
Centimeters	Inches	0.4
Feet	Centimeters	30.5
Centimeters	Feet	0.03
Yards	Meters	0.9
Meters	Yards	1.1

WHITE CHAIR
watercolor on 300-lb. (640gsm) cold-pressed paper
15" × 21" (38cm × 53cm)

ACKNOWLEDGMENTS

I would like to first and foremost thank God for giving me this talent and the opportunity to use and show my talent by way of this book.

Next I would like to take this opportunity to thank a number of family members and friends who encouraged me along the way, particularly my former college instructor, Mr. Jon Henderson, who was persistent about my finishing college and assisting me in most important ways to ensure my graduating. My wife, Rena, for putting up with my art life. My sons, Rodney, Reginald and Ryan, who were always an encouragement. My editors, Jeffrey Blocksidge, Mary Burzlaff and especially Jennifer Lepore, who gave me valuable advice and assistance. And to Jamie Markle—without his help, this book would not have been possible. Jamie, I owe you big time! I could not end this acknowledgment without thanking Mrs. Shirley Fordham for her valued friendship and support while working on this book.

DEDICATION

I would like to dedicate this book to my friend and art partner, Leroy Allen, who passed away two years ago, and to my many friends who encouraged me throughout the making of this book. Thanks to all!

TABLE OF CONTENTS

MATERIALS AND TECHNIQUES *10*

Find the right tools for the job and learn how to use them to create amazing watercolors.

PEOPLE PART 1
28

Learn to paint skin color and hair, then follow along to paint people of all ages, indoors and outside.

DEMONSTRATIONS

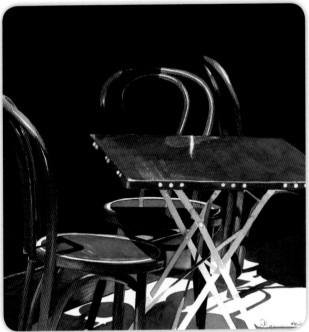

PLACES PART 2 *62*

Capture the drama of the landscape as you paint the city and the country, mountains and lakes.

DEMONSTRATIONS

THINGS PART 3 *100*

Paint interesting compositions using everyday objects such as fruit, glass, lace, tables and chairs.

DEMONSTRATIONS

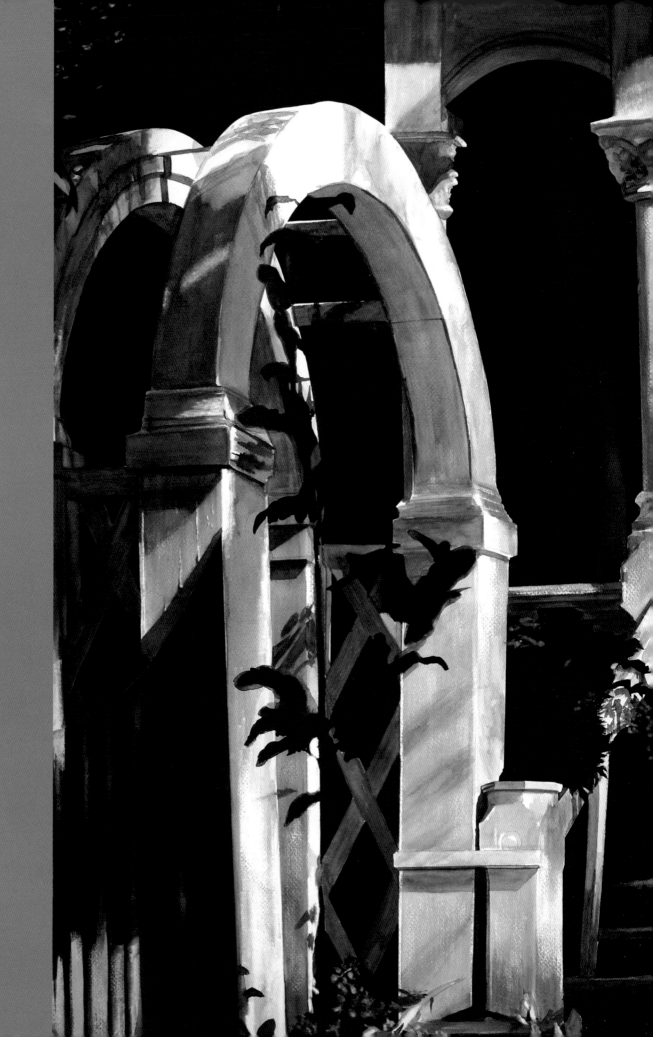

8

INTRODUCTION

As a boy growing up in Chicago, I developed an interest in drawing. So much so that I got into trouble in class because of it. I drew cowboys instead of doing my class work, which didn't include drawing.

It wasn't until I moved to Michigan and attended art school at Western Michigan University that I developed a serious interest in art and photography. It was in Art History when I observed the beautiful watercolor works of John Singer Sargent that I realized watercolor was the medium for me. But, much to my disappointment, watercolor and I didn't quite get along at first. When I tried watercolor in college, I felt that the medium was controlling me instead of me controlling it. So I abandoned watercolor and began painting in gouache, a choice that offered me more control.

I knew watercolor was the medium I wanted to excel in but I didn't get it to work for me, that is until in 1993, after an almost thirty-year pause, a little voice inside prompted me to try again. This time the process seemed to come naturally, as if I'd never put down my watercolor brush. Why the sudden change? Because I'd let the medium intimidate me earlier, I think I kind of relaxed more when I got back into it. Now I'm in control.

After graduation from graduate school I started traveling more. During my travels I realized that there was more subject matter out there to paint than I had originally realized. It was then I found a huge cross section of subject matter to paint that could fall under *People*, *Places* and *Things*.

My favorite subjects are scenes of old Victorian houses, landscapes of canyons and rocky-surfaced mountains, and people in everyday situations. With the latter, I have an affinity for depicting children and elderly people, whose countenance and actions seem so uncontrived and natural. I've recognized this quality in the works of such great artists as John Singer Sargent and Winslow Homer.

While traveling to the U.S. Virgin Islands and other islands as well as most of the continental United States, I decided to take along one of my favorite tools for capturing those everyday moments—my camera. It's a professional one with which I can isolate the exact scenes I want, especially since I sometimes like to paint locations that have a strong light source. The camera of choice for me now is a digital camera; it allows me to work out all the compositional elements I want to include in my work.

My primary goal when painting with watercolor is to represent reality—not to be photographic in appearance—but to reflect my response to the scene sincerely. This sincerity is the reason for my painting. I want to evoke mood, emotion and feeling in the viewer. From an artistic standpoint, the most important thing is to create a striking composition rather than just painting a person, a landscape or a thing on paper.

In this book I will share with you many years of experience in observing and painting a wide variety of *People*, *Places* and *Things*, and hope you will be inspired to paint them also.

ARCHES
watercolor on 300-lb. (640gsm) cold-pressed paper
35" × 21" (89cm × 53cm)

FIND THE RIGHT TOOL FOR THE JOB

As an artist, you may have accumulated an assortment of materials and tools suitable for your own style and method of painting. You may even have strong personal preferences for materials and perhaps shortcuts that are highly *your style.* However, the materials and tools you use should be determined by the subject you have selected.

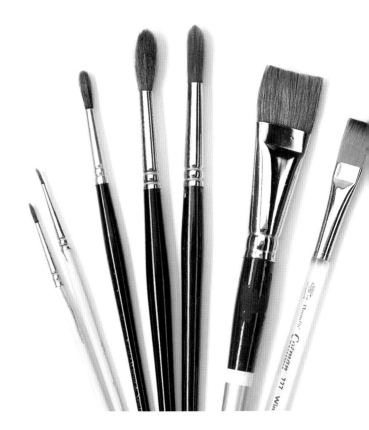

SABLE BRUSHES

Winsor & Newton Series 7 Pure Kolinsky Red Sable brushes are undoubtedly the finest, but are very expensive. However, there are many good synthetic brands on the market today, which are a relatively inexpensive alternative.

As a rule of thumb, select a round brush that will hold a good quantity of water and see if it holds a point. If the hairs separate and cannot form a point nor spring back to its original shape, it is of inferior quality.

I use a wide range of round sables—nos. 0, 2, 4, 6, 10, 14. I use a ¾-inch (19mm) and 1-inch (25mm) flat brush for broad washes. And, I've trimmed some old bristle brushes to use for lifting out areas of color in my paintings.

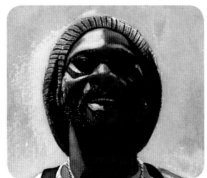

CONTROLLED STROKES

With a no. 4 sable round you can control layering in small spaces.

FINE DETAILS

A no. 2 sable round works well for small details such as the grooves in this man's hat.

LOOSER STROKES

A no. 6 sable round is a good choice for the loose, curved strokes used to depict waves.

I usually research the Old Masters to see how they selected the materials for their masterpieces. Sometimes a great piece of art grows out of other art, so if you are inspired to paint a still life in the manner of Winslow Homer or even Sargent, refer to a book on these artists and see how they achieved their effects and what materials and tools they used.

WASH BRUSH

A 3-inch (76mm) bamboo handle brush with soft bristles is ideal for making very broad strokes of wash.

CRAFT KNIFE

A craft knife handle and no. 616 or 11 blades are used for scratching out color in specified areas of the painting. This technique should be done on a completely dried surface, not wet, or this will destroy the paper's surface.

Use the craft knife to create dimension in grasses or for highlights in hair.

Pencils

I use pencils to transfer an image to watercolor paper with an opaque projector. I also use pencils with soft lead, such as a 4B or 6B pencil, to coat the back of a sheet of tracing paper that has the image drawn on it. I use it like carbon paper to transfer the image to watercolor paper.

It is best to use softer leads in the B range as you can erase them almost completely, with little to no trace of graphite remaining on your paper. Too hard a pencil (in the H range) will tend to leave traces of lead and scar the paper.

SANDPAPER

Use 220-grit sandpaper for creating the rough surface appearance of rocks and concrete, such as this close-up of a sidewalk.

MORE HELPFUL TOOLS

COTTON SWABS
Lifting out color with a cotton swab will give you very soft edges.

SCRUBBER
An oil painting brush with some of the bristles cut away is another great tool for lifting out color.

MASKING FLUID
Use masking fluid to preserve areas of a painting for later in the composition.

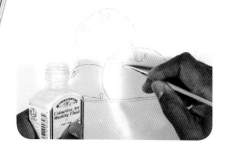

Apply the masking fluid with a fine-point brush to the area you want to preserve (such as a highlight).

Once the paint is dry, use a rubber pickup or your fingertip to remove the mask. Then soften the edges around the highlighted area and add color if desired.

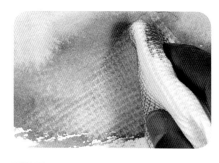

TEXTURED FABRIC
The use of a textured fabric, such as a piece of thermal cloth, on a partially dried wash is a quick way to add a textured pattern to your painting.

ROCK SALT
Salt creates interesting, organic texture. Apply the salt on a medium to dark wash. Let it stand for a few minutes and watch the color leave the surface of the paper. After the paint has dried, you can add a diluted version of same color or a different color over the salt-drawn area for a layered effect.

SPONGES
Certain sponges, especially natural sponges, can be used to establish and create certain textures, such as small rock formations and piles of rock.

WATERCOLOR PAPER

Watercolor papers come in a variety of weights, materials and surfaces. The best papers are made of 100 percent rag and are acid-free. They are buffered against environmental contamination and can withstand the test of time without turning yellow. The lesser quality papers will not. The weights or thickness of papers range from 70 lb. (150gsm) to 400 lb. (840gsm) and the surfaces are hot press, cold press and rough.

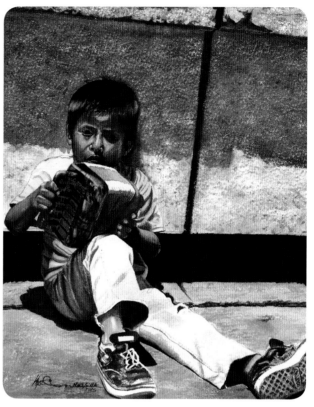

COLD PRESS
Cold-pressed paper has a fairly rough (medium texture) surface and is probably the best all-around paper.

HOT PRESS
Hot-pressed paper has a smooth, slick surface that makes it very difficult to control washes. It doesn't absorb well.

ROUGH
Rough paper has a great deal of texture. It gives good, "dry-brush" quality but paint tends to dry spotty.

CHOOSING A SURFACE FOR YOUR SUBJECT
A cold-pressed watercolor paper was the perfect choice for this piece. Its semi-textured surface along with a dry-brush paint application was a match for the texture of the background and foreground, helping set the mood of the piece.

PERSISTENCE
watercolor on 300-lb. (640gsm) cold-pressed paper
13" × 10" (33cm × 25cm)

Watercolor Paper

Because I do not stretch my paper, my paper of choice is 300-lb. (640gsm) cold press. I paint directly onto unstretched paper, and when it dries I dampen the reverse side of the painting, place a large piece of clean plywood or particle board on top of the painting, weight the board down and allow the paper to dry perfectly flat. Heavier paper (300 lb. [640gsm] or 400 lb. [840gsm]) tends to show very little buckling or warping, if any, depending on how much wash is applied.

PAINTS AND THEIR CHARACTERISTICS

There are several excellent brand-name watercolor pigments on the market, such as Winsor & Newton, Grumbacher and Holbein. The color may vary slightly between brands but the quality remains consistently high. Experiment with different brands to see which best meet your needs.

Watercolor pigments are generally sold in metal tubes and metal or plastic pans. The tube pigment is a moist paste that you squeeze out onto your palette. The pigment in the pan is dry, but dissolves as soon as water is applied with a brush. The pans are useful especially for small paintings on location. In this book we will use tube pigments as their moist composition makes quick work of laying washes of paint, no matter how big the painting.

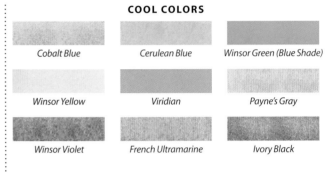

WARM COLORS			COOL COLORS		
Cadmium Yellow	Cadmium Red	Alizarin Crimson	Cobalt Blue	Cerulean Blue	Winsor Green (Blue Shade)
Permanent Rose	Olive Green	Permanent Sap Green	Winsor Yellow	Viridian	Payne's Gray
Yellow Ochre	Raw Sienna	Burnt Sienna	Winsor Violet	French Ultramarine	Ivory Black
Burnt Umber	Winsor Blue (Green Shade)				

WARM VERSUS COOL

Using warm or cool colors depends primarily on the type of scene you're painting. Natural warm colors—reds, oranges, yellows, browns—you would tend to see more in a fall, rural scene. Cool colors—blues, grays, some greens—are primarily seen in wintery, cloudy and foggy scenes.

You can break these categories down further within each color family—for instance, Cadmium Yellow is a warmer yellow than Winsor Yellow, and Alizarin Crimson is a warmer red than Permanent Rose.

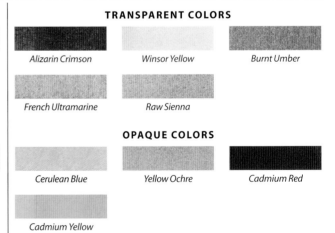

STAINING COLORS			TRANSPARENT COLORS		
Winsor Yellow	Winsor Blue (Green Shade)	Alizarin Crimson	Alizarin Crimson	Winsor Yellow	Burnt Umber
Winsor Green (Blue Shade)			French Ultramarine	Raw Sienna	

NON-STAINING COLORS			OPAQUE COLORS		
Cobalt Blue	Viridian	Raw Sienna	Cerulean Blue	Yellow Ochre	Cadmium Red
			Cadmium Yellow		

STAINING VS. NONSTAINING

Nonstaining pigments such as Cobalt Blue, Raw Sienna and Viridian can be lightened or easily lifted out without ill effect.

Staining pigments such as Winsor Yellow, Winsor Blue (Green Shade), Alizarin Crimson and Winsor Green (Blue Shade) will stain the paper, preventing lifting out of color.

TRANSPARENT VS. OPAQUE

Opaque, sedimentary pigments such as Cerulean Blue, Yellow Ochre, Cadmium Red and Cadmium Yellow obscure much of the paper or underlying pigment and are effective in conveying weight and density. Colors such as Alizarin Crimson, Winsor Yellow, Burnt Umber, French Ultramarine and Raw Sienna are more transparent, allowing for glazing and layering so the bottom layers and the white of the paper shine through.

CHOOSING YOUR COLORS

In a perfect world, you would need only three tubes of watercolor paint (red, yellow and blue) because in theory every other color is a mixture of these three primary colors. Unfortunately, combining pigments diminishes their brilliance, and the green you mixed with blue and yellow is less intense than one squeezed from a tube marked *green*. Therefore, an artist's palette of colors isn't "set in stone." Instead, it is a highly personal collection of warm and cool pigments that reflects the artist's taste. See below for a good starter palette.

Although there are those who will not recommend black, there are times when I think it is needed. But again, that is at your discretion. You can get a warm black by mixing Alizarin Crimson and Winsor Green (Blue Shade) or Hooker's Green, and a cool black by mixing French Ultramarine, Winsor Green (Blue Shade) and Alizarin Crimson.

I do not, however, recommend using a tube White as it is too opaque, and you will have a brighter, fresher look if you use the white of the paper for white highlights, etc.

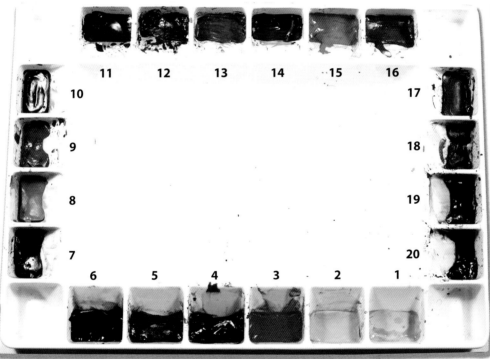

MY FAVORITE COLORS

This is my palette of choice, filled with the colors I typically use. I include warm and cool versions of every color family (greens, earth colors, reds, yellow and blues), as well as Payne's Gray and Ivory Black.

1 Winsor Yellow
2 Cadmium Yellow
3 Cadmium Red
4 Alizarin Crimson
5 Permanent Rose
6 Winsor Violet
7 French Ultramarine
8 Cerulean Blue
9 Cobalt Blue
10 Winsor Blue (GS)
11 Winsor Green (BS)
12 Viridian
13 Olive Green
14 Permanent Sap Green
15 Yellow Ochre
16 Raw Sienna
17 Burnt Sienna
18 Burnt Umber
19 Payne's Gray
20 Ivory Black

Choosing a Palette

Selecting a palette is a matter of personal choice, but be sure you choose one that has deep wells and large areas for mixing washes. Also make sure the palette is white and preferably made of a material that has a surface that doesn't stain readily.

I like to arrange my palette similar to a typical color wheel because I can find the colors much faster. I won't have to search for them. You don't want to have to stop and look around the palette for a certain color while the wash is drying.

PAINTING ON LOCATION

Many watercolorists consider location painting (away from the studio) to be the ultimate art experience. They believe that you get a much truer sense of color and space.

When you work on location you can begin and complete paintings all at once, although you may have to work faster than usual due to impending inclement weather. You may also choose to start painting on location and finish it the studio, taking extra time to gather resource information.

Working outdoors or even indoors away from the home studio requires more organization than working in your own indoor studio, so plan your painting trips carefully. It's an excellent idea to make a checklist of materials and supplies to include for your trip. You may also need a few pieces of special equipment. A small folding stool or chair and a compact easel are essential for portability. A small mat cut as a frame to use for planning your composition is also handy.

To keep from running around all over the place with your painting equipment looking for a good spot to paint from, it's best to plan this in advance. Explore the prospective area the day before and choose your spot so you go straight to painting once you get there.

EQUIPMENT FOR PAINTING ON LOCATION

- Brushes—3 or 4 different sizes
- Paint box—A good variety of colors
- Tube colors and mixing pans
- Sketching block or light drawing board and sheets of paper
- Several weights of watercolor paper
- Bottle or jar for carrying water
- Plastic jar for paint water
- Pencil and eraser for preliminary drawing
- Knife for sharpening pencil
- Sketching stool
- Sponges and paper towels for general mopping up
- Large plastic bag to protect your work in case of rain
- Viewfinder for determining composition

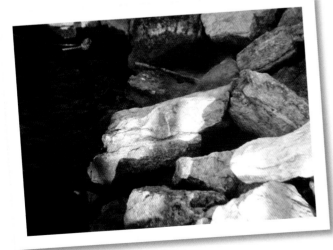

Reference photograph taken at Longview Lake.

I sketched these rocks at Longview Lake to capture the strong contrasts of light and cast shadows that attracted me to this scene.

PAINTING IN THE STUDIO

If you are not an artist who likes to paint on location, the next best option is painting from photographs in the comfort of your studio. Your own photographs are your best source for paintings. They show the subjects you prefer and reveal your own sense of visual design.

Some painters frown on the use of photographs, but although there are good reasons for this (colors may not be true, photos can hinder your creativity, you may be tempted to paint everything you see instead of being selective), it makes more sense to look at your position realistically. After all, most of us don't usually have a great deal of time at our disposal. If you've set aside a day for painting a landscape and it is pouring down rain, it's more satisfying to paint a similar subject from a photograph than not to paint at all.

STUDIO SETUP

Because I predominantly work in my home studio, much of everything I need is at my fingertips. Whether I'm standing or sitting, I use a large C-legged drafting table for painting, plastic containers to hold water, several containers to hold my brushes, several lights to work by, a few select brushes and a watercolor palette with about twenty-four colors that I have squeezed out of the tubes.

Painting in the studio offers me a *comfort zone* in several ways. I'm not concerned about nasty weather. I'm not so concerned about bees, wasps, flies, snakes and other little pesky critters. It's also nice to know that I can leave my unfinished painting where it is and know it will not be tampered with. It's so nice to know that I have that comfort zone to work in. Any artist can tell you that you, as an artist, can produce your best work in the best environment. For me, that's my studio.

Painting With Natural Light

Many artists prefer to paint with light from a north-facing window, as it is a cool, constant and clear light. North light does not cast heavy, changing shadows and enables you to work through the day without worrying about the position of the sun. This can be extremely helpful if you want to work continuously on a portrait or still life that may take several days to complete.

TAKING PHOTOGRAPHS

Many artists are notorious for braving severe topography, extreme weather and insects to seek just the right outdoor location. Sometimes such sketching and painting experiences are not possible. Maybe it's raining, the light or mood is quickly changing, there isn't any level space to set up your easel, you're moving in a vehicle and happen to notice that "great subject," or you need time to study details but the animals will not sit still. In these and many other cases, photography comes to the rescue.

There were several realist artists of the past, one being Gustave Courbet, who were introduced to the camera and its possibilities and declared it to be a "unique sketchbook." The role of the camera to artists is to help you remember and understand what you see. It is then your role as artist to go beyond the obvious and bring out the subjective feelings you have for a particular subject. Your own photographs will be your best source for paintings because they show the subjects you record and reveal your own sense of visual design.

DIGITAL CAMERAS

Some people have said that digital cameras are really microprocessors with lenses attached, and they aren't far off. The sensor in the camera captures the image information, and then the image processor in the camera goes to work. You can shoot on what's called the *default* or *factory* settings mode (that is how the manufacturer thinks your pictures should look), but you also can set up the ISO, saturation, sharpness and even choose whether to shoot in color or black and white.

A digital camera allows you to take hundreds of photos quickly

Digital SLR Camera

so you have plenty to choose from for reference; I would suggest a 64MB or higher memory card for this reason.

Once the image is captured on your memory card, the process is hardly over. After downloading the image to your computer, you can manipulate the image in a variety of ways, so much so that you can even correct flaws that would otherwise cause you to trash the picture. Apart from image fixes, there is a whole new realm of creativity where your imagination can run wild!

35MM SLR (FILM) CAMERA

The single-lens reflex (SLR) is the most successful of all camera designs. This remarkable achievement has happened through the recent advances in design and innovation. There are many advantages with the SLR: It is lightweight, easy to handle and operate, compact, has eye-level viewing, a built-in exposure meter and an astonishing array of interchangeable lenses. The SLR receives the image through the camera lens onto an angled, moveable mirror that transfers the image to a glass screen. The image is identical to the one received by the film. A spring mechanism links the mirror to a focal plane shutter release, so when the shutter is tripped the mirror automatically snaps out of the path of exposure.

Standard SLR Camera

For shooting with a standard 35mm SLR camera, I use Ektachrome 160 Tungsten slide film. These slides produce fantastic color, are stored easily and can be quickly dropped into a carousel to view and reference with a slide projector.

COLOR VS. BLACK AND WHITE

Black-and-white photos help you see value contrasts, light, shadow and form. They encourage you to be interpretive in your selection of colors. If you are painting in a photorealistic style (producing a painting that looks like a photograph), color photography will serve your needs best.

■ Learning How to Take Good Photographs

No matter what your photography skill level, taking good photographs takes work.

Talking to other photographers and researching through books, magazine articles and online resources will be a big help in improving your skills.

My favorite book getting started was *Kodak Guide to 35mm Photography*. (I used the 1989 edition published by Eastman Kodak Company, but the newer edition from Sterling Publishing has great reviews as well.)

DIGITAL MANIPULATION

Digital images make photo improvements easy! I took these photos from inside a building on a rainy day. The colors of the photo on the left are drab and the raindrops on the window are distracting. As seen in the photo on the right, I made this scene much brighter, intensified the colors and cloned out some of the distracting droplets by using Adobe Photoshop imaging software. It can be a time-consuming process to alter images on a computer, but it can also be a whole lot of fun.

PHOTOGRAPHING INDOOR SUBJECTS

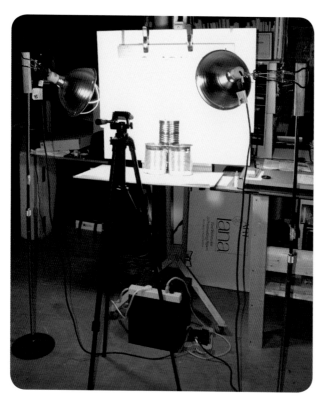

To create a dramatic painting, choosing the type of light source most desirable to you can be just as important as choosing the right subject matter.

Sometimes a subject, depending on how it's lit, can be more dynamic indoors drenched in natural light streaming through a window as opposed to outdoors in natural light.

There are other occasions when an artificial light source can evoke a much more dynamic mood than the natural light from the sun. You have to experiment.

Your camera's flash unit can sometimes give you an extra light boost. A double light source can create interesting shadows. When shooting with a flash or double light source, let one light source dominate while the other complements and enhances the main source. Remember to *experiment* to see what looks best for your needs.

SETTING UP YOUR ARTIFICIAL LIGHTING
- **Backdrop**—Clamp white foamboard onto an easel to block out objects in the background.
- **Photo lamps**—Place 500-watt floodlights evenly on either side of the object.
- **Tripod**—Always use a tripod to avoid blurred photos due to camera movement.

USING MULTIPLE LIGHT SOURCES
Notice the subtle secondary light source on the right side of the bag. You can make more complex patterns of light and shadow by introducing a second or even a third spotlight and shining them onto the subject from different directions.

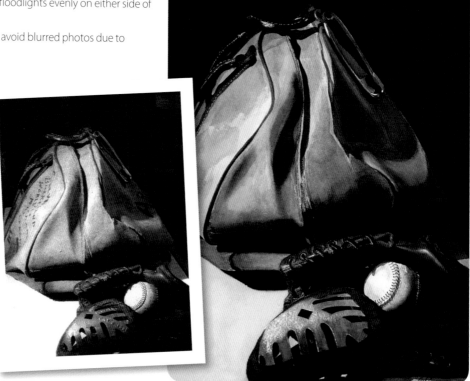

LEGACY OF FORGOTTEN LEAGUES
watercolor on 300-lb. (640gsm) cold-pressed paper
19" × 15" (48cm × 38cm)

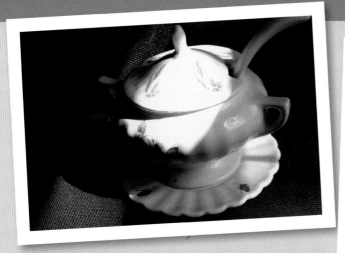

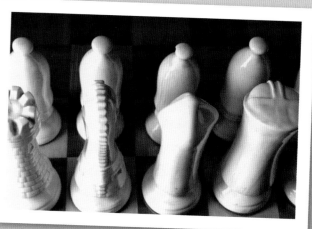

NATURAL LIGHT FROM A WINDOW

Try to make your lighting of the subject as dramatic and powerful as you can so you can produce a more dynamic painting. In most cases, natural sunlight through a window will by itself produce dramatic lighting with dynamic shadows, no matter what the subject. This bowl was shot at 1/15 sec at f8.

NATURAL, REFLECTED LIGHT

Notice how the sunlight streaming through the window onto the ceramic chess pieces has a slightly different effect on each piece. The light from the piece on the right is reflected onto the piece on the left. This photo was shot at 1/13 sec at f8.

ONE LIGHT SOURCE—ARTIFICIAL

When shooting with an artificial light source, you may have to move the light source around to get good shadows and lighting situations, especially if it's a single light source. In this photo, the lighting is directly overhead, causing short shadows. If you want longer shadows, the light would have to be moved. This photo was shot at 1/20 sec at f8.

You might also consider incorporating the light source itself into the composition. Table or floor lamps can create a cozy and intimate mood.

TWO LIGHT SOURCES— ARTIFICIAL

The lighting here is a two-light-source setup. This situation will usually produce much softer shadows when lit evenly from both sources. However, if one light is strong and the other gives just a hint of light, you will produce a more dramatic setting. This grouping was shot at 1/15 sec at f8.

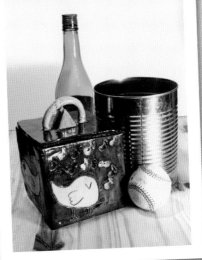

◼ Finding a Subject Indoors

There are no hard-and-fast rules as to the best place to photograph your images. But there is one place you can always photograph without being told you are trespassing, and that is your own home. Believe it or not, there are some great subjects within your own home to photograph for painting, and you don't even have to set up anything special—just photograph what you see.

PHOTOGRAPHING OUTDOOR SUBJECTS

Photographing outdoors is generally not as restrictive as shooting indoors. All of nature is at your fingertips.

Parks, markets and busy downtown streets are great venues for photographing people. Rural countryside offers a wide variety of pastoral subject matter. For wildlife artists, the city zoo is an excellent inexpensive venue for photographing subject matter. Not everyone can afford to go on a wildlife safari in Africa. Take advantage of every opportunity available for your use.

Vacations are a great way to get photo reference material. Since you're there, you may as well put your camera to good use. Once you have returned to your studio, you can arrange the photos according to painting potential. You should look for a photograph that will take you as far as possible in evoking that special feeling as the painting develops.

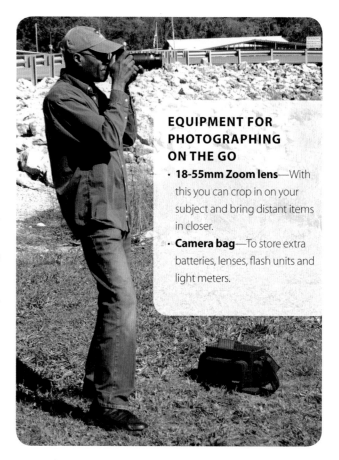

EQUIPMENT FOR PHOTOGRAPHING ON THE GO

- **18-55mm Zoom lens**—With this you can crop in on your subject and bring distant items in closer.
- **Camera bag**—To store extra batteries, lenses, flash units and light meters.

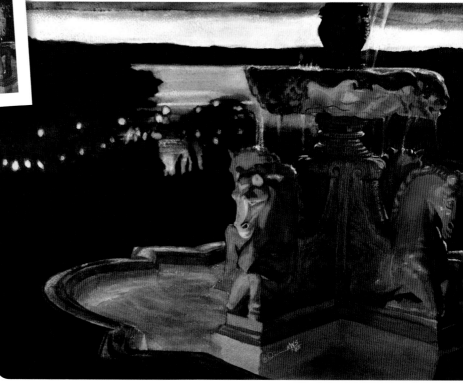

NIGHT OR DUSK
Shooting in low light such as this will require the use of a tripod. Set your camera to a very slow speed (1/8 sec at f8 or f16).

NIGHT VISION 4—TABLEROCK LAKE
watercolor on 300-lb. (640gsm) cold-pressed paper
18" × 24" (46cm × 61cm)

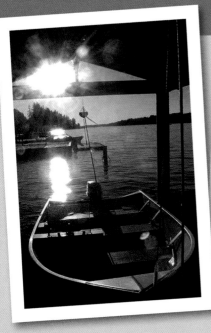

SUNSET

Because of the angle of the sun when setting, the light is usually most prominent on top surfaces. Notice the top edge and seats of the boat. To photograph this situation you will need a tripod, setting your camera to a slow speed (1/60 sec at f4).

DIRECT SUNLIGHT

Direct sunlight on the subject produces very strong shadows. For photographing subjects in intense and direct sunlight, it's best to shoot at a fast speed (1/250 sec at f5.6 or higher). In general, take pictures in bright sunlight with the sun coming in from the side or at an interesting angle to your subject. This situation usually produces dramatic compositions.

REFLECTED OR INDIRECT SUNLIGHT

In this photo there are no hard-edged shadows, only soft shadows indicating that the light is not direct, but bouncing or reflecting off another object onto the subject. Since it is still bright sunlight, shoot these situations at high speeds (such as 1/160 sec at f8).

SUNNY SHADE
OR "CLOSED SHADE"

This kind of lighting is produced when your subject is in the shadow of an overhanging structure such as an awning or building structure as shown in this photo. This type of photography requires shooting at a slower speed than with direct sunlight, probably 1/125 sec or slower at f4 or f8. Shooting at a slow speed generally requires the use of a tripod to steady the camera when you are depressing the shutter button.

COMPOSING YOUR SUBJECT

The most important element an artist can add to a painting is a dynamic composition. Composition is defined as "the organization of the parts of a work to achieve a unified whole." These parts are the basic elements of a good composition: space, depth, form and dimension. We as artists are limited to a flat two-dimensional surface of a specific area to create these illusions.

Composition is a balance of all the elements and images on "your" picture plane to obtain your desired effect. Plan your composition in the beginning, before you start painting. The camera will give you a frame of reference that just looking at a subject with your eyes cannot give you. Use that reference to initiate your composition.

Start your compositions with a basic rectangular shape. Pick a subject or subjects and look at them through your camera's viewfinder. By fitting the subject within the viewfinder, you can zoom in to or out from the subject to determine how you want to compose your picture.

CROPPING PHOTOS WITH AN ADJUSTABLE VIEWFINDER

Your photograph should be approximately 4" x 6" (10cm x 15cm)—large enough to effectively use the adjustable viewfinder. Simply enlarge the photo by scanning it and enlarging it on your computer's imaging software and print it.

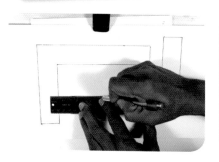

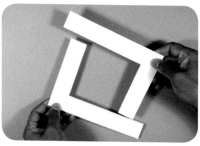

Draw two L-shaped frame halves on a white mat board (8" x 5½" x 1¼" [20cm x 14cm x 3cm]). Use a straightedge or ruler and cut them out with a mat knife or craft knife.

Put the two halves together and adjust the opening to a desirable size and shape to obtain your composition.

MINIMIZING DETAIL WITH YOUR CAMERA

If you want to photograph a person and there are trees in the background with all kinds of detail in the leaves, branches and twigs but you want to focus on the person, the camera's depth of field can bring the figure into sharp focus while making the background elements blurred or out of focus, basically *minimizing the detail*. You can manipulate your camera's depth-of-field feature by employing a few simple settings to the camera—a small lens opening will give greater depth of field than a large lens opening. If you focus the lens on the foreground, objects in the distance or background will be fuzzy or out of focus (above left). When you focus the lens on the distant background, objects in the foreground will be fuzzy or out of focus (above right).

CROPPING WITH YOUR CAMERA'S VIEWFINDER

Most amateur photographers and artists set out to take pictures and are not all that concerned about composition at the onset. As a water-color artist, I have learned over the years that whatever my subject matter is I should shoot for good composition. In other words, plan the shot by *cropping* within the viewfinder. This is more easily done if you are using a camera with a telephoto lens. You can virtually stand in one spot and go through a series of crops of your subject matter. Crop carefully when you take the picture. To emphasize the subject, show it *big* and eliminate extraneous elements. When you look through your viewfinder, move toward your subject, or if you're using a telephoto lens, zoom in until you have eliminated everything that does not add to the composition.

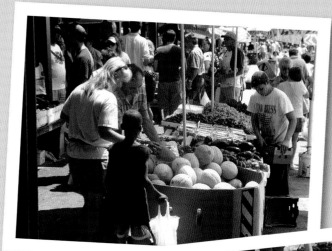

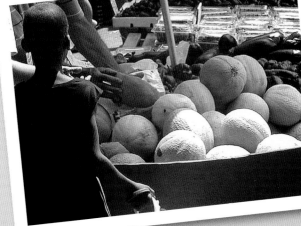

Transfer Your Photo With a Computer

This method of transfer allows you to easily increase or decrease the size of your photo. With your computer, you can also adjust colors and darken shadows or lighten the composition to help define shapes where needed.

1 SCAN THE ORIGINAL PHOTOGRAPH
Scan your photo and enlarge it in Adobe Photoshop or a similar imaging software to the size you decided the painting should be.

2 DIVIDE THE ENLARGED IMAGE
Divide the image by cropping it into different sections, making them into separate printable files. You can have as many as four to eight different files, depending on how large you want the painting.

3 PUT THE FILES TOGETHER
Print out the enlarged files and tape them together to match the original photograph.

4 TRACE THE IMAGE
Tape a piece of tracing paper over the enlarged image and use a 3B drawing pencil to trace the entire image. This step will also allow you to make changes to your composition if you so desire.

5 APPLY GRAPHITE
Flip the traced drawing and apply graphite to the back of the image lines only. This will save time as opposed to spreading graphite on the entire surface of the tracing paper.

6 TRANSFER THE IMAGE
Flip the tracing paper over to the original drawing side, tape it over your watercolor paper and trace over the lines of the image with a red ballpoint pen. A pen is harder, rolls smoothly and will not tear the tracing paper as easily as a pencil. The red color shows where you've already traced. Do not press too hard. Once the transfer is complete, you can add areas where you want more shadows, etc. Now you can start painting.

Transfer Your Photo With a Projector

Projecting your image onto a wall allows you to make last-minute changes to your composition, while still viewing the original image. Working at actual size, you can change a background and add or subtract items with ease.

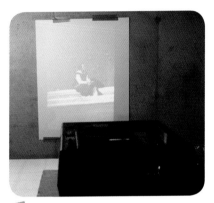

1 PROJECT THE IMAGE
Set up a projector with a slide of your image. Tape a full sheet of white mat board to an available wall and project and center the image.

2 PREPARE YOUR SURFACE
Tape a piece of tracing paper to the mat board. Tape at the top and bottom to secure the tracing paper.

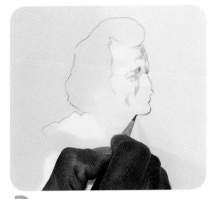

3 TRACE THE IMAGE
Start drawing the image onto the tracing paper. At this point, you can add or subtract from the image as you deem necessary for a pleasing composition.

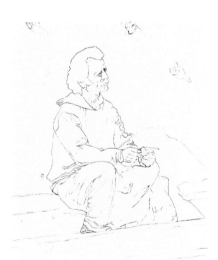

4 TRANSFER THE IMAGE
When you are done tracing, flip the paper over and follow steps 5 and 6 from the demo on the opposite page.

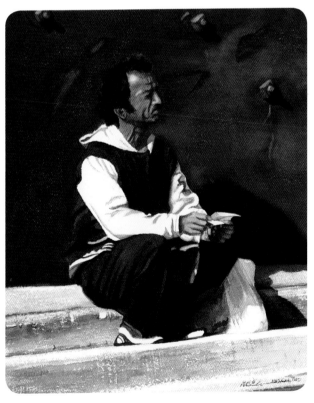

RED WALL
watercolor on 300-lb. (640gsm) cold-pressed paper
15" × 13" (38cm × 33cm)

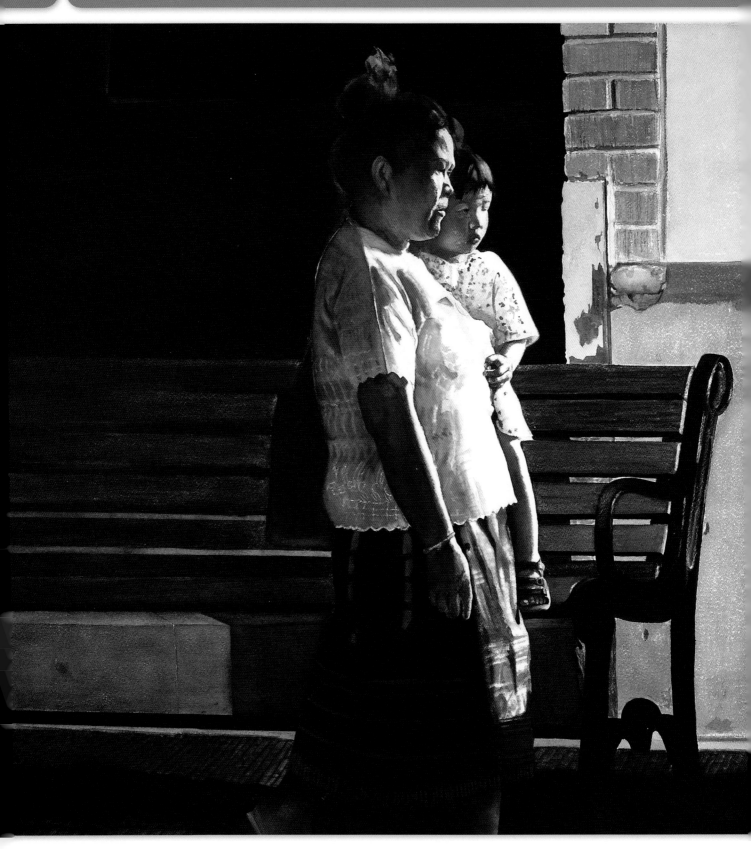

QUIET STROLL
watercolor on 300-lb. (640gsm) cold-pressed paper
22" × 30" (56cm × 76cm)

PEOPLE

I have always been a people person, observing people, socializing with people. I especially enjoy painting people, probably because they can't talk back or argue with me at that point. I enjoy the challenge of painting figures. My favorite class in college was my life drawing or figure drawing class.

I like the challenge of painting people in everyday situations—in casual situations, even in not-so-happy situations. The nice thing about photographing people in everyday situations is that if you have captured a bunch of people in order to get the few you wanted, you can isolate the people you prefer to paint when the film is developed or when the digital image has been captured, even place them wherever you want within the composition.

MATERIALS

SURFACE
300-lb. (640gsm) cold-pressed paper

BRUSHES
Nos. 2, 4, 8 sable rounds

PIGMENTS
Alizarin Crimson

Burnt Sienna

Cerulean Blue

French Ultramarine

Ivory Black

Winsor Green (Yellow Shade)

Yellow Ochre

OTHER SUPPLIES
3B pencil

Kneaded eraser

Transfer paper

I make certain to always carry a camera with me on vacation. While on a trip with family, I separated myself from the group to search for interesting people to photograph. The prospects were numerous. You can see a person of much interest to paint and the person is surrounded by much clutter, but you take the photograph anyway. The nice thing about painting from photos is that you can totally eliminate the clutter.

My goal here was to use watercolor to interpret a skin tone quite different from my own and to render it as accurately as possible.

REFERENCE PHOTO
This particular gentleman captured my attention very quickly; primarily because he is an elderly person with deep ruddy red skin. I liked the spiked appearance of his hair, the deep lines in his face and the drapery effects of the white shirt over his shoulders.

1 DEFINE THE FORM
Draw the figure from the photograph onto tracing paper, and then transfer it to your watercolor paper. This initial pencil drawing will begin to define the form with highlights and shadows. With a kneaded eraser, lighten the lines where the edges of the lightest washes will follow so the pencil line won't show through after the wash dries. In the dark areas such as the hair, eyebrow and around the edges of the trousers, you can leave the lines dark as the dark washes will cover those lines.

2 ADD BASE COLOR TO THE FACE

Mix a light value of Alizarin Crimson and Yellow Ochre and apply it all over the facial area with a no. 4 or no. 8 sable round, painting well past the hairline. When the initial layer has completely dried, add another layer to heighten the skin tone. This man's skin color will have a reddish brown appearance as it gets.darker.

3 APPLY SHADOWS AND LINES

Working from lights to darks, brush one glaze over another with a no. 4 sable round, allowing each to dry in between. Add more of the same paint to the mix you already have for the face to intensify the color. Add a small amount of French Ultramarine to that color until you get a midrange liver color and apply that to the front of the face—around the eye, nose, front of cheek, lip, chin and neck areas to establish the shadows and lines.

For the first application of hair color, create a slightly darker than midrange value mix from Alizarin Crimson, Winsor Green and French Ultramarine. This mixture will be your black, or you can simply use Ivory Black straight out of the tube. Apply this to the hair and mustache areas with a no. 4 sable round, leaving the white of the paper in areas that will represent highlights and gray hair. You can refine the gray and highlights later in the painting.

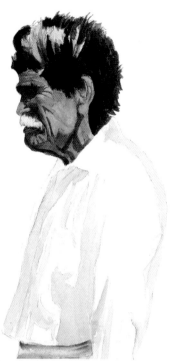

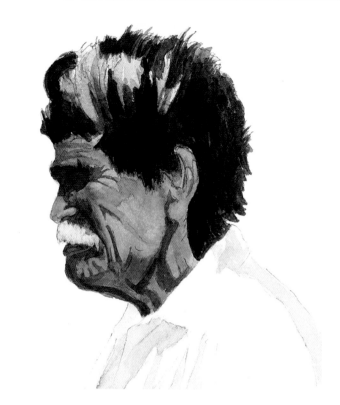

4 DEEPEN THE SKIN TONES AND HAIR

By adding another glaze of the deeper color wash for the skin, you give the Mexican man a more natural skin color and tone. Refine the shadows and lines of the face. Block in the shadows of the white shirt with a mix of Alizarin Crimson and Cerulean Blue. Much of the white of the shirt should be the untouched white of the watercolor paper. Add color to the trousers with a Cerulean Blue/French Ultramarine mix. Continue to darken the hair as well. Lift the color out of the mustache with a damp no. 4 sable round.

5 PLAN THE BACKGROUND

Paint the background with a no. 4 sable round in various tones, using the mix of Alizarin Crimson, Cerulean Blue, French Ultramarine and a small amount of Ivory Black; the background is lightest at the top and darkest at the bottom. Apply a first layer, let dry and then apply a second, still with the lightest at the top and the darkest at the bottom.

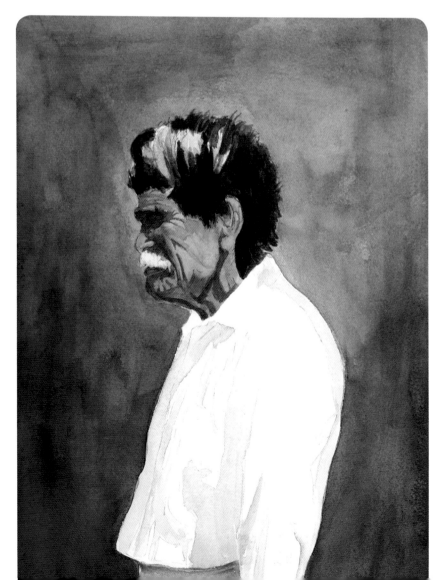

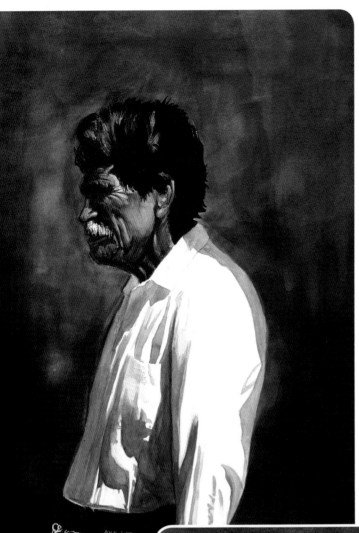

6 THE FINAL STAGE

In the finishing details of the painting, start with the head and work your way down. Apply the black mixture to the hair, leaving the highlights and the gray. Use a no. 2 sable round to paint single strands of hair around the outside of the head. The location of the single strands are up to you. Go back into the hair and drag some black paint into the light gray areas to make them a slightly darker gray. You can finish the hair by scratching out lighter strands for more pronounced highlights.

Prepare a darker mixture of the original for the face: Alizarin Crimson, Yellow Ochre and Burnt Sienna with a small amount of Ivory Black. Use this wash for the shadow around the eye, nose, chin and neck as well as the lines around the eye, ear and neck areas. Add more Ivory Black for the much darker lines of the neck and eyebrow.

For the shirt, you can make a midrange-to-dark mixture for the shadows using a mix of Cerulean Blue, Alizarin Crimson and a small amount of French Ultramarine. In the area of the shirt pocket and underneath the collar, use a wash of Yellow Ochre to show a yellowish glow of sunlight.

For the highlights of the blue jeans, use a midrange mixture of French Ultramarine and Cerulean Blue.

OLD SEÑOR
watercolor on 300-lb. (640gsm) cold-pressed paper
17" × 12" (43cm × 30cm)

HAIR

MATERIALS

SURFACE
300-lb. (640gsm) cold-pressed paper

BRUSHES
1½-inch (38mm) flat

Nos. 4, 6, 8 sable rounds

No. 6 synthetic round

PIGMENTS
Alizarin Crimson

Burnt Sienna

Burnt Umber

Cerulean Blue

Cobalt Blue

French Ultramarine

Hooker's Green

Ivory Black

Viridian

Winsor Green (Blue Shade)

Yellow Ochre

OTHER SUPPLIES
3B pencil

Cotton swab

Craft knife with no. 616 blade

Masking fluid

Rubber cement pickup

The principles for painting hair are the same, no matter what the color, value or texture. Overall we should remember that hair has a naturally soft texture and that softening the edges is one way to describe this texture. Sometimes we make painting hair much harder than it really is. Just remember the following tips: Be careful not to make hard edges, especially precise lines where the hair meets the face. A hard-edged hair line around the face will tend to make the hair look like a wig. Make sure the transition between the hair and the skin is subtle and irregular. This transition is more difficult with darker hair but is easier as the hair gets lighter. For this demonstration you'll be painting dark or black hair with a fine, smooth texture.

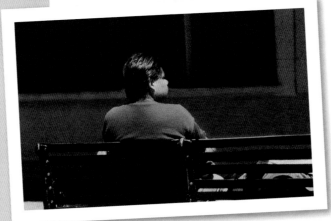

REFERENCE PHOTO
Although the painting is still recognizable based on the photograph, I excluded many of the other elements to focus on the one male figure on the bench in order to make a stronger statement and composition.

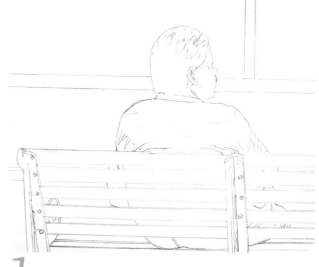

1 ESTABLISH THE FOUNDATION
After drawing in the composition, I cropped in to create a stronger design, placing the man a little off center. I also eliminated the clutter in the window to keep the composition as simple as possible and focused on the man.

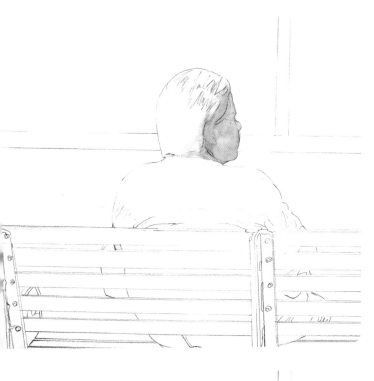

2 LAY THE FIRST WASH

Once you've sketched in your subject, there are two approaches to take. You can paint in just the face with a no. 6 sable round and a very light mixture of Alizarin Crimson and Yellow Ochre and wait for it to dry. Make sure the color is applied well past the hairline because the dark color of the hair will cover the light skin tone of the face. Or, you can paint in the whole face and hair area at one time and wait for it to dry before applying another layer of wash. It doesn't matter which approach you choose; the results will be the same. For the lightest areas, leave some white paper untouched by paint or blot with a damp cotton swab to lift out the highlights.

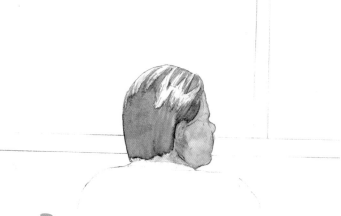

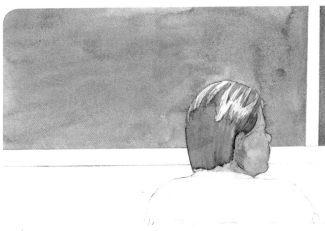

3 BEGIN THE HAIR

Since the hair is black, start out with a medium-range gray to establish where you want to place your highlights and darkest blacks. Use a no. 4 sable round and Ivory Black from the tube, or mix your own black using Alizarin Crimson and Winsor Green or Hooker's Green. If you choose to mix your own, however, use a medium range of the mix to start in case you decide to add more highlights and need to lift out paint later. Let this dry completely before applying the next layer. Follow the contour of the head when applying all washes to the hair.

4 PAINT THE BACKGROUND

Use your 1½-inch (38mm) flat or no. 6 sable round to wash a preliminary mix of French Ultramarine, Alizarin Crimson and Viridian in the upper half of the background. This cool black will contrast with and set off the head of the man. Let this wash dry thoroughly.

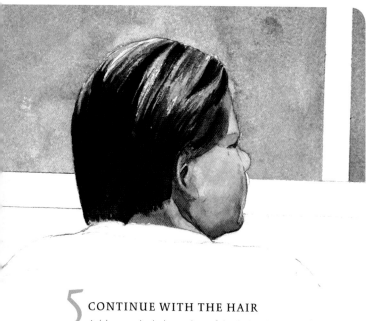

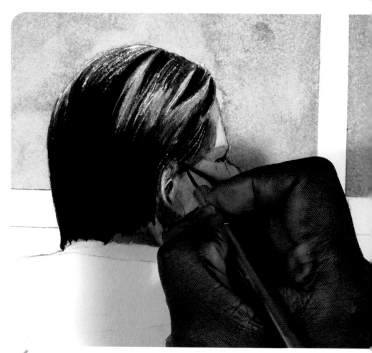

5 CONTINUE WITH THE HAIR

Add a much darker value of the hair mixture in the shaded area of the hair by applying a mix of French Ultramarine and Alizarin Crimson with a no. 6 sable round. Keep fine streaks of dark value in the highlighted area to show that the hair is black. Leave selected medium-gray areas as a midrange light source.

Add a small amount of the hair mixture to darken the face mixture and use this to fill in some of the detail of the face. Add the shadow under the cheek and chin areas as well as around the eye.

6 FINISH THE HAIR

Use a craft knife to lightly scratch out thin hairs that are the extremely highlighted strands of hair. Do this only after the applied wash has dried. Be sure not to overdue the scratching or your results may be too busy.

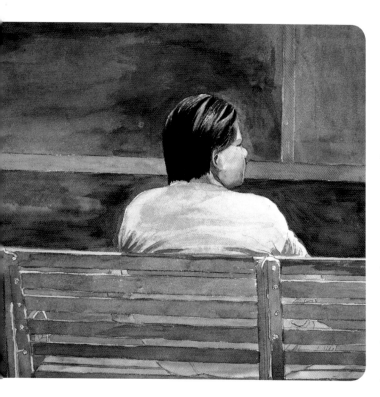

7 DEVELOP THE BACKGROUND

Now, it's just a matter of mixing the paint to finish the painting. Use a no. 8 sable round for this step. For the man's shirt, use a mixture of Cerulean Blue, French Ultramarine and a small amount of Alizarin Crimson. For his blue jeans, use French Ultramarine and Cobalt Blue. For the trim on the window in the background, use Alizarin Crimson, Yellow Ochre and Burnt Sienna. For the wall under the window, mix Burnt Sienna, Yellow Ochre and French Ultramarine. For the highlights on the bench, use Yellow Ochre and a small amount of Alizarin Crimson. For the back of the bench, use a mixture of Burnt Umber, Alizarin Crimson, French Ultramarine and a small amount of Ivory Black. For the seat of the bench, mix a darker version of the mixture for the highlights on the bench. Before applying any paint, apply some masking fluid with a no. 6 synthetic round to all highlighted areas of the bench, including the nuts and bolts on the rear of the bench, and let dry. Apply the washes to all the areas listed in a midrange wash and allow to completely dry. Paint right over the masking fluid.

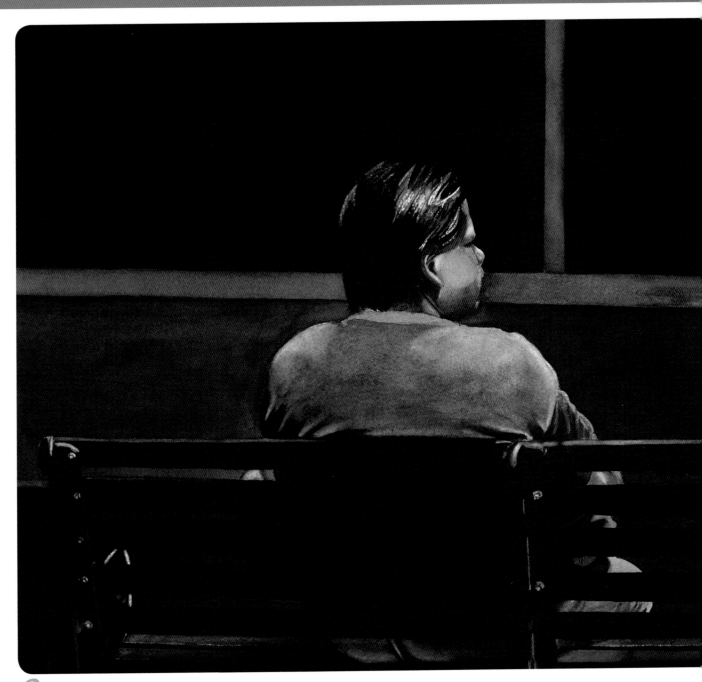

8 FINISH THE PAINTING

Next, make a more concentrated, but not opaque, version of each of the washes in step 7 and finish the painting using a no. 6 sable round. After drying, remove the masking fluid with a rubber cement pickup. Now it's time to finish painting the nuts and bolts on the bench with a midrange version of the color for the slats on the bench. You don't want to make the nuts and bolts too dark as they are just in the shadow. Use a cotton swab or damp sable brush to lift out paint from the seat of the man's jeans and from the seat of the bench.

TIJUANA MAN
watercolor on 300-lb. (640gsm) cold-pressed paper
15" × 23" (38cm × 58cm)

PAINT PEOPLE OUTDOORS

MATERIALS

SURFACE
300-lb. (640gsm) cold-pressed paper

BRUSHES
Nos. 4 and 6 sable rounds

PIGMENTS
Alizarin Crimson

Burnt Umber

Cadmium Orange

Cerulean Blue

Cobalt Blue

French Ultramarine

Permanent Rose

Yellow Ochre

OTHER SUPPLIES
220-grit sandpaper

3B pencil

Cotton swab

Kneaded eraser

Outdoor light isn't predictable or controllable: If you are drawn to paint the strong shadows and contrasts that occur on a sunny day, it's much easier to take a photograph of the scene, rather than try to paint on location. On a sunny day, the light changes quickly and the shadows you loved will move and change as well. When you're photographing to paint in your studio, all you need to do is to wait for the right moment, then shoot. You never have to worry about losing that moment. It is forever captured on film.

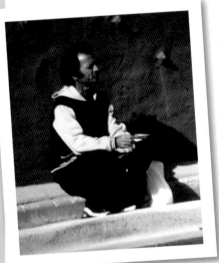

REFERENCE PHOTO
The contrast between the man's clothing and the red wall of the building behind him really drew me into the scene, as did the man's shadow on the wall and on the steps and the shadows from the nuts and bolts on the side of the building.

1 PREPARE AND TRANSFER THE IMAGE
After carefully masking off your painting area, transfer the image with a 3B pencil. Because of the softness of the lead, it will enable you to easily erase it with a kneaded eraser prior to painting, leaving very little or no trace of the line.

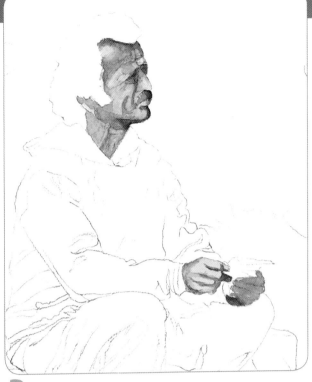

2 APPLY THE FIRST WASH

Before applying any pigment, lightly erase the lines, leaving enough to show the area where you will apply the wash. When painting people, concentrate on the skin color first. Using a no. 6 sable round and a mixture of Alizarin Crimson, Yellow Ochre and a very small amount of Cerulean Blue, lay in a diluted wash of pigment in the hands and face.

3 BRING OUT THE DETAIL

Add another layer of the same mixture in and around the facial features and hands with a no. 6 sable round to bring out the form and features. For the lightest areas, leave some white paper untouched by paint or blot with a damp cotton swab to lift out the highlights.

4 IMPROVE THE SKIN TONE

Add a thin glaze of Yellow Ochre with a no. 4 sable round to make the skin tone a little richer. Also deepen the shadows using a mix of Alizarin Crimson, Yellow Ochre and a touch of Cerulean Blue to further bring out the form and features of the face and hands. Add a pale mix of Permanent Rose, French Ultramarine and Burnt Umber in the hair, mustache and eyebrows to bring out the facial color.

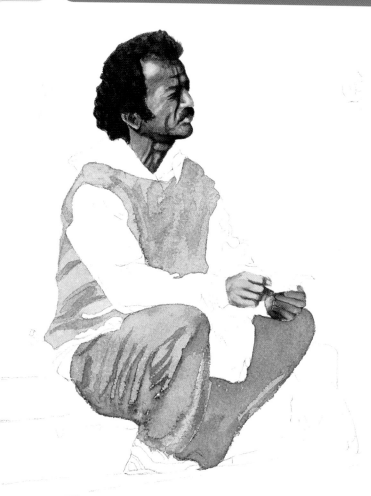

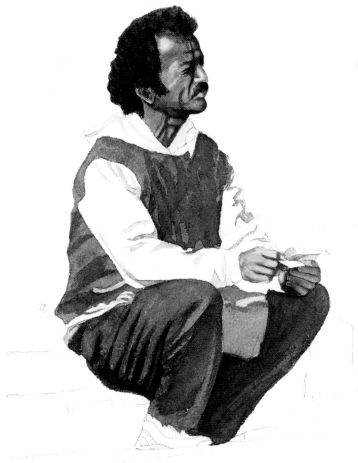

5 LAY A WASH ON THE CLOTHES

Apply a medium wash mixture of French Ultramarine, Alizarin Crimson and Burnt Umber to the clothed area with a no. 4 sable round. Thin the mix enough to allow the lines to show through and let the wash dry completely.

6 DETAIL THE CLOTHES

Further refining the detail in the clothing begins to bring reality into focus. Use a no. 6 sable round and French Ultramarine to add the folds and wrinkles to form shadows in the areas that fit loosely. Leave highlights on the jacket and pants where the knees and elbows bend and sunlight strikes the surfaces.

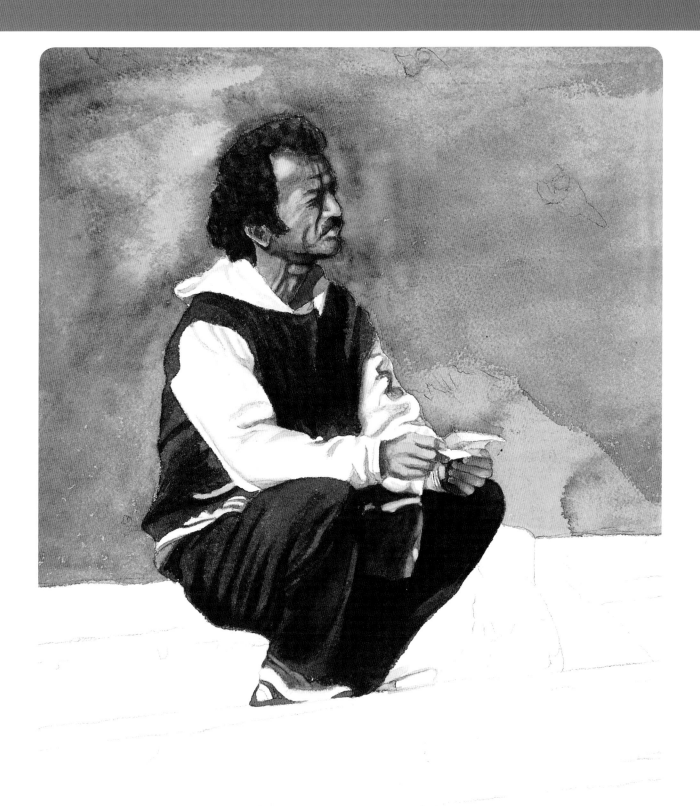

7 START THE BACKGROUND

Add finishing touches to the forehead area and on the hands (especially between the fingers) using a no. 6 sable round and a mix of Alizarin Crimson, Yellow Ochre and Cobalt Blue. Add a darker version of this mix under the chin and on the neck area. Then lay an initial wash on the background wall with a mix of Alizarin Crimson, French Ultramarine and Cadmium Orange.

8 APPLY A SECOND WASH TO THE WALL

Because the background wall is such a large area to cover, it's a good idea to apply the wash in small amounts to avoid a puddling effect. Apply the wash with a very damp brush in approximately 1- to 2-inch (25mm to 51mm) blocks at a time, not allowing the edges to dry. It's OK if the color is uneven as this will just add to the texture of the wall.

9 DETAIL THE WALL

Add the shadow of the figure and bring in other compositional elements on the wall using a no. 4 sable round with a French Ultramarine/Alizarin Crimson mix.

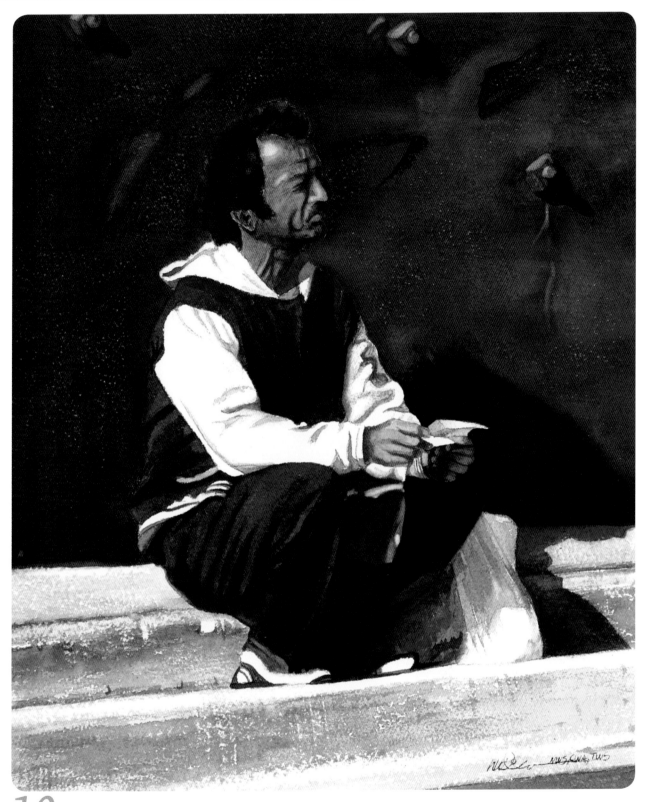

10 TIME TO REACH A CONCLUSION

Pull it all together by painting the steps that the man is sitting on, using your no. 6 sable round and a mix of Yellow Ochre, Cerulean Blue, Alizarin Crimson and French Ultramarine. Allow the paint to dry, then use 220-grit sandpaper on the steps to give them the appearance of old concrete.

RED WALL
watercolor on 300-lb. (640gsm) cold-pressed paper
15" × 13" (38cm × 33cm)

PAINT PEOPLE INDOORS

MATERIALS

SURFACE
300-lb. (640gsm) cold-pressed paper

BRUSHES
½-inch (13mm) flat

Nos. 4 and 6 sable rounds

No. 6 synthetic round

PIGMENTS
Alizarin Crimson

Burnt Sienna

Cerulean Blue

Cobalt Blue

French Ultramarine

Ivory Black

Viridian

Yellow Ochre

OTHER SUPPLIES
220-grit sandpaper

3B pencil

Cotton swab

Craft knife with no. 616 blade

Kneaded eraser

Masking fluid

Rubber cement pickup

Lighting is the major factor when photographing people indoors to paint later in the studio. The type of lighting you choose will greatly affect the emphasis and mood of the painting. Light controls the emotional impact of a painting and evokes life and meaning for the subject.

Decide whether to employ artificial light or to use natural light flowing through a window. Opening a curtain to expose a figure to natural light poses a different set of challenges than turning on a lamp. Be aware of how the light falls on the subject. You can also control lighting on your figure by adjusting the aperture and speed settings of your camera.

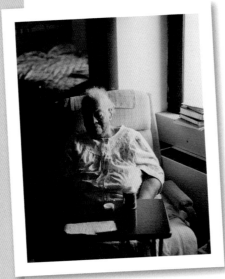

REFERENCE PHOTO
This photograph is of my wife's godmother, who at the time was 101 years old. The brightness of the sunlight streaming through the window and the time of day made for a rich and lively light source for the subject. Although the photo is rather complex and cluttered, I chose to trim the fat, so to speak.

1 DEFINE THE SHAPES
Start with a preliminary pencil drawing to define the shapes of the figure and shadows on the figure. You'll also want to define the background elements (the bed and bed coverings in the bedroom), as well as the foreground elements (the table and objects on it, and the telephone in the lower right corner). At this point it's important to visualize the flat shapes, which the brush will carefully follow. The pencil drawing will also define where the light that's coming through the window falls on the figure and other objects.

APPLY THE FIRST WASH

Before any pigment is applied, use a kneaded eraser to lightly erase over the lines, leaving enough to just barely define the shapes. Mix up a very pale wash of Yellow Ochre, Alizarin Crimson, Burnt Sienna and a small amount of Cobalt Blue. Apply the paint with an almost dry to medium-wet no. 6 sable round. At this point, don't be concerned about the shadows.

CONTINUE THE SKIN COLOR

Once the paint dries, add a little more of the same mixture from step 2 along with a small amount of French Ultramarine to darken the mix just a bit. Define the form of the face and arms with the shadows and lines of the facial features using a no. 6 sable round.

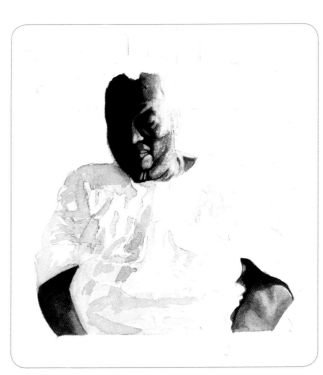

REFINE AND ADD DETAIL

Darken the skin mixture further with a more concentrated blend of Alizarin Crimson, Yellow Ochre and Burnt Sienna and apply with a no. 4 sable round for the shadows on the face and arms, giving those areas more shape and form. As you add more detail and refine the figure more, use the very tip of the damp brush to soften the hard edges of the washes, blending more with the lighter values that are next to the darker values. Now start adding the shadows and folds to the elderly lady's dress using a pale mixture of Cerulean Blue and Alizarin Crimson applied lightly in the shadow areas.

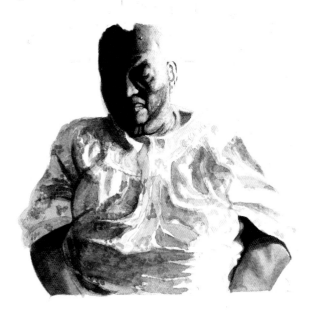

5 ADD MORE DETAIL

Add the floral detail to the dress with Alizarin Crimson, Cobalt Blue and Viridian using a no. 4 sable round. Prepare a medium-dark mixture of Viridian and Cobalt Blue until you have a medium pale blue-green. Keep the Alizarin Crimson separate. Start adding the floral pattern on top of the shaded area you created in step 4. If you need to, continue to work on the arms and face detail, being careful not to overwork those areas.

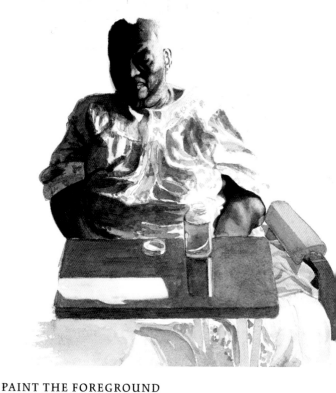

6 PAINT THE FOREGROUND

Preserve the light patch on the table with masking fluid using a no. 6 synthetic round, then use a no. 4 sable round to apply a pale mixture of French Ultramarine, Burnt Sienna, Yellow Ochre and a small amount of Alizarin Crimson to the table and chair. Use a pale mixture of Alizarin Crimson and Cobalt Blue for the bottom part of the dress.

When dry, remove the mask from the table with a rubber cement pickup and paint in the tissue with a pale blend of Burnt Sienna and Yellow Ochre.

Add color to the pill bottle and cap with a mixture of French Ultramarine and Cobalt Blue. Add a shadow from the bottle on the table with a more concentrated mix of the table color.

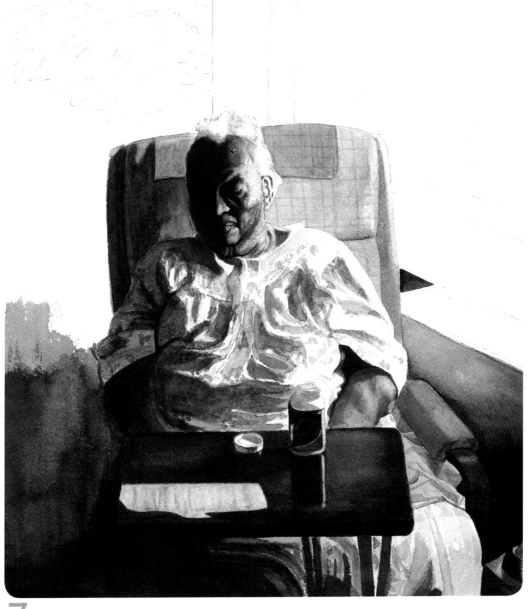

7 DETAIL THE FOREGROUND

Begin strengthening all of the colors mentioned in step 6 to intensify the elements in the foreground, giving them shape and making them recognizable. Darken the table with a stronger mix of Burnt Sienna, Alizarin Crimson, Yellow Ochre and a small amount of Ivory Black. Let this completely dry. Then, with a dampened cotton swab or a ½-inch (13mm) flat, gently lift out some of the color from the area next to the bottle for the reflection of light on the table.

Continue with the mix you used for the chair in step 6, then when dry add the fabric details with a midrange mix of Cobalt Blue using the pointed tip of a no. 4 sable round.

Add strong shadows to the right of the chair, underneath the table and to the left of the chair using a mixture of French Ultramarine, Alizarin Crimson and a small amount of Ivory Black. Start out with a pale mixture and layer it with a denser mixture to get to a rich, dark shadow. Allow each layer to completely dry. Wipe out some color under the windowsill to show reflected light.

8 BUILD UP THE BACKGROUND

Use a no. 4 sable round to paint the door trim with an Alizarin Crimson, Burnt Sienna and French Ultramarine mix. Paint the side of the heater, window and walls with a light mixture of Yellow Ochre and Alizarin Crimson. Add the dark window trim and grate on the top of the heater with a French Ultramarine and Cobalt Blue mix.

Use shades of the shadow mix from step 7 (French Ultramarine, Alizarin Crimson and a small amount of Ivory Black) to paint the background bedroom, leaning more toward Alizarin Crimson as the bed brightens, and adding the door trim color mix on the bed posts.

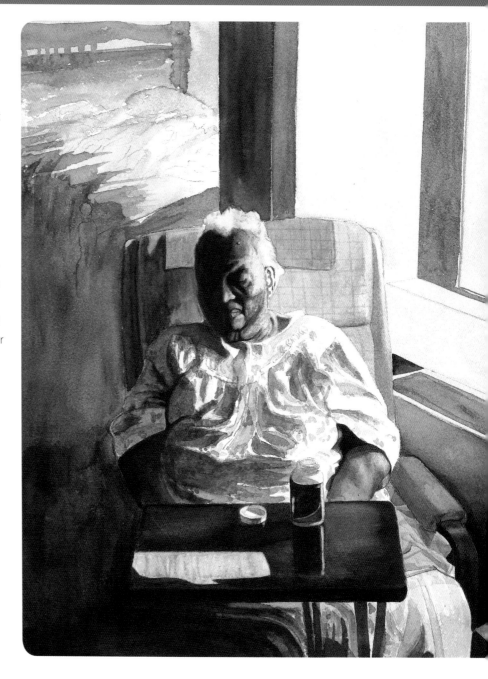

9 COMPLETE THE PAINTING

Deepen all the shadows in the foreground and background using a no. 4 sable round with a very dark mixture of French Ultramarine, Alizarin Crimson and Ivory Black. If needed, simplify the shadowed area underneath the table in front of the woman by lifting out some paint with a damp no. 6 sable round or a damp cotton swab. Feather out the shadow from the dark at the bottom to the lighter value at the top of the heater on the right. Use a piece of 220-grit sandpaper and gently rub over the wall behind the chair to give it a rough plaster look. Use a craft knife to gently scratch out the highlights on the bedpost at the foot of the bed as well as for the highlight on the right corner of the table.

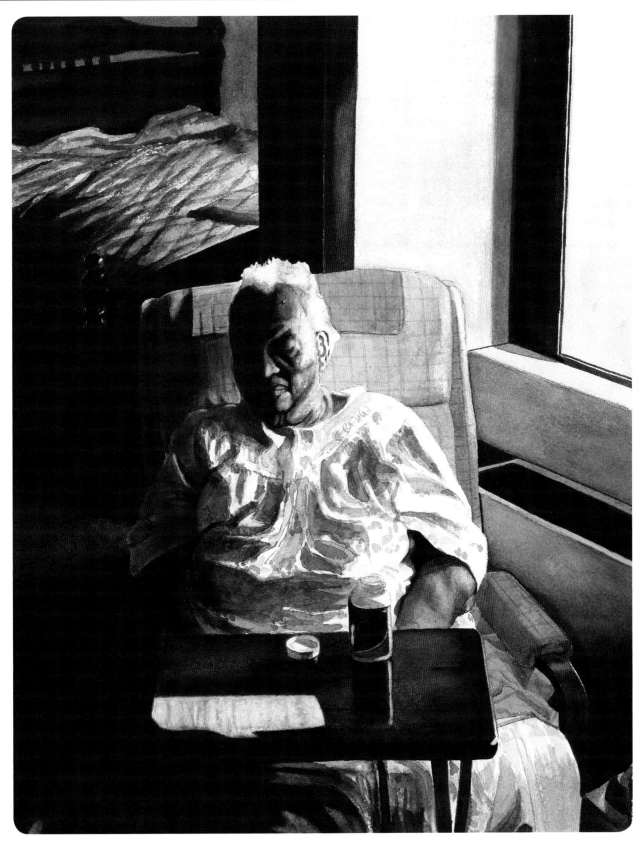

CLARA'S HOME
watercolor on 300-lb. (640gsm) cold-pressed paper
15" × 12" (38cm × 30cm)

MATERIALS

SURFACE
300-lb. (640gsm) cold-pressed paper

BRUSHES
Nos. 2, 3, 4, 6, 8, 10 sable rounds

PIGMENTS
Alizarin Crimson

Cadmium Yellow

Cerulean Blue

Cobalt Blue

French Ultramarine

Ivory Black

Viridian

Yellow Ochre

OTHER SUPPLIES
220-grit sandpaper

3B pencil

Kneaded eraser

Painting children has long been a passion of mine because their demeanor is always so unpretentious and honest. With children, what you see is what you get; one learns that if you want to paint children, photography may not be the only option, but it's the best option. I don't know that I would assume a small child would sit still for me while I painted his or her portrait, nor would I want them to.

Children are constantly changing as they grow older, so it's important that when you paint a four-year-old, you don't want the child looking like a seven- or eight-year-old. The secret is in the proportion of the head to the entire body: torso, arms and legs. The relationship between head length and total body length changes with each year the child grows.

REFERENCE PHOTO
While I was out looking for interesting painting subjects to photograph, this youth playing his accordion captured my attention. I was quite drawn to the soft appearance of his skin in contrast to the rough texture of the wall behind him.

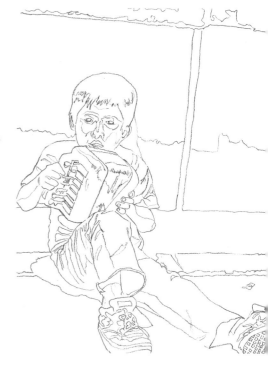

1 ESTABLISH A FOUNDATION
Create the compositional structure of the painting and draw in the child paying attention to his proportion—make his head big relative to the rest of the body. Pinpoint the basic shapes of the shadows as well.

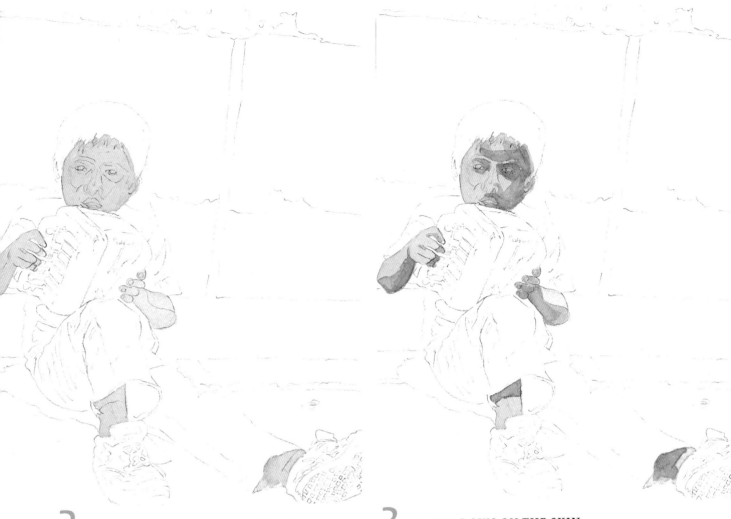

2 APPLY THE FIRST WASH TO THE SKIN

Before applying any pigment, lightly erase the lines, leaving enough to show the area where you will apply the wash. Because this particular child is of Mexican descent, keep the flesh tones at a warm temperature. Use a no. 6 sable round to apply a diluted or pale wash of Alizarin Crimson and Yellow Ochre on all the skin areas, extending the color well beyond the hairline on the head so the hair will not look pasted on later in the painting. Paint right over the features and details of the face and hands. They will be added in later. Let these areas dry.

3 ADD SHADOWS ON THE SKIN

Mix a thin wash of Alizarin Crimson and Cobalt Blue and paint in the dark shapes of the shadow areas around the eyes, forehead, cheeks, mouth, nose, hands, arms and legs. Add a bit more warm color into the skin with a no. 3 or no. 4 sable round and a medium-dark mixture of Alizarin Crimson, Yellow Ochre and a small amount of Cobalt Blue. For now, you just want to create the basic shape of the shadows.

4 DARKEN SHADOWS AND PAINT THE HAIR

After the applications in step 3 have dried, continue to darken the shadows on the skin with a no. 6 sable round and additional layers of the same mixture, softening the edges of the applied washes to bring out the form of the face, hands and arms. Start painting the hair with a medium-dark mix of Alizarin Crimson, French Ultramarine and Ivory Black. Use this same mixture for the eyes. When applying the brushstrokes for the hair, make sure you follow the contour of the head.

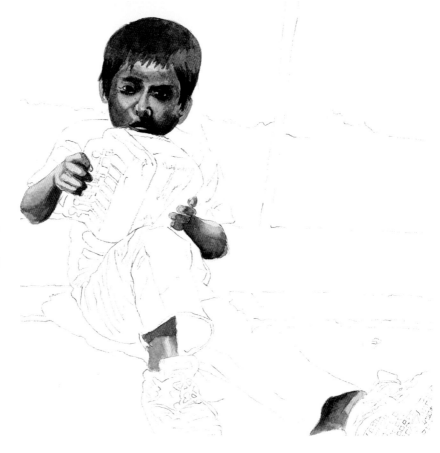

5 PAINT THE CLOTHES

While still refining the skin tones, details of the face and fingers, begin painting the shirt and trousers with a no. 6 sable round. For the shirt, use a mixture of Cerulean Blue and a small amount of Alizarin Crimson. Leave the areas of the shirt that are directly in the sunlight a lighter version of this mixture. The cast shadows such as those cast by the child's arms are going to be darker than the rest of the shadows within the shirt, such as in the folds.

For the trousers, add a midvalue mix of Alizarin Crimson and Yellow Ochre.

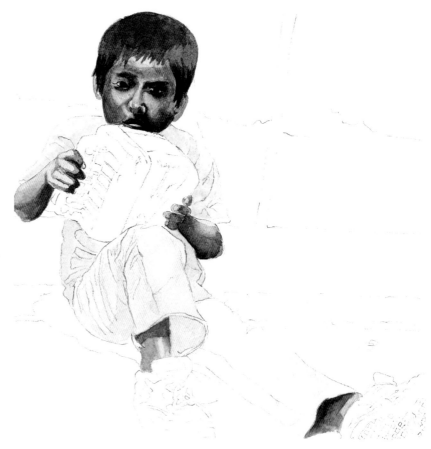

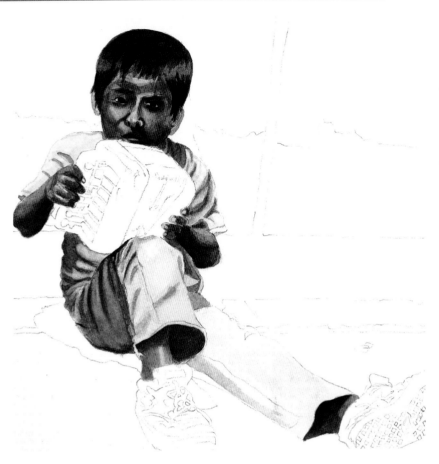

6 DEFINE SHADOWS IN THE CLOTHES

Build the dark shadows of the shirt and trousers with layers. Paint the darks in the shirt and model them with warm and cool variations of Cerulean Blue and Alizarin Crimson, using a no. 6 sable round. At this stage, keep the shapes simple. For the shadows and folds in the trousers, add more Alizarin Crimson and Yellow Ochre with a touch of French Ultramarine to bring out the form of the folds within the shadow under the accordion.

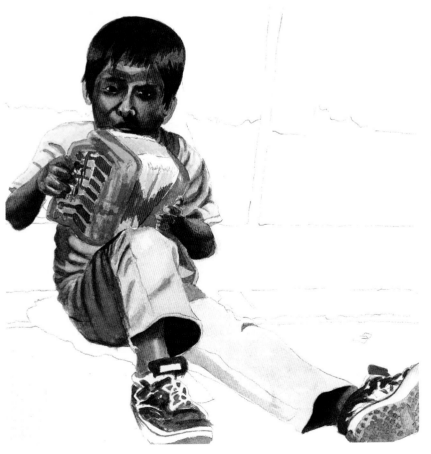

7 PAINT THE ACCESSORIES

For the shoes, mix Alizarin Crimson and Viridian to get a good midvalue black and apply with a no. 6 sable round. Paint around the shoelaces, leaving the white of the paper to show for white shoelaces.

For the accordion, use a mix of Alizarin Crimson, Cadmium Yellow, Viridian, Cerulean Blue and Ivory Black. Mix Alizarin Crimson and Cadmium Yellow for the orange keys, and use Viridian and Cadmium Yellow for the case of the accordion with Ivory Black touches to give it a tortoiseshell appearance. For the bellows of the accordion, mix a small amount of Alizarin Crimson and more Cerulean Blue for the blue areas, and Alizarin Crimson and Cadmium Yellow for the orange area. Leave the white of the paper for the white bands on both sides of the blue band.

8 WORK IN THE DETAILS

Because the left side of the accordion is away from the direct sunlight, darken those colors with a midvalue of French Ultramarine using a no. 6 sable round. Then begin painting in the background and establish the basic shapes of the shadows in the concrete background and foreground. Mix Yellow Ochre, Alizarin Crimson and French Ultramarine and apply all over both areas with a no. 8 or no. 10 sable round. Let dry and apply a second layer in shadow areas.

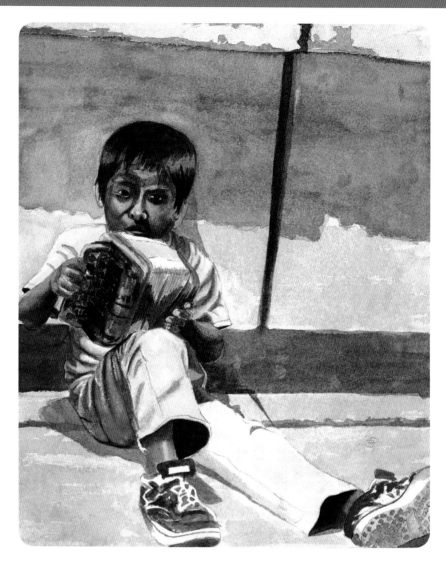

9 THE FINAL TOUCHES

In this final stage, concentrate on the details of the entire painting using a no. 4 sable round. Add more French Ultramarine to the wash and darken the shadow at the top of the wall. Paint the space at the bottom of the wall completely black using several layers of Ivory Black. Using a dark mix of French Ultramarine and Ivory Black, fill in the vertical space in the center of the wall to the right of the boy, and layer in the horizontal crack in the sidewalk directly behind the boy. To give the appearance of rough concrete, use a piece of 220-grit sandpaper and gently rub the surface of the watercolor paper on the wall to expose the high areas of the textured paper surface.

For the fine detail in the hair and other smaller details on the boy, use a no. 2 or no. 3 sable round. Continue to add layers of previous colors to the boy and the accordion, developing the contrasts between light and shadow to finish his form and features.

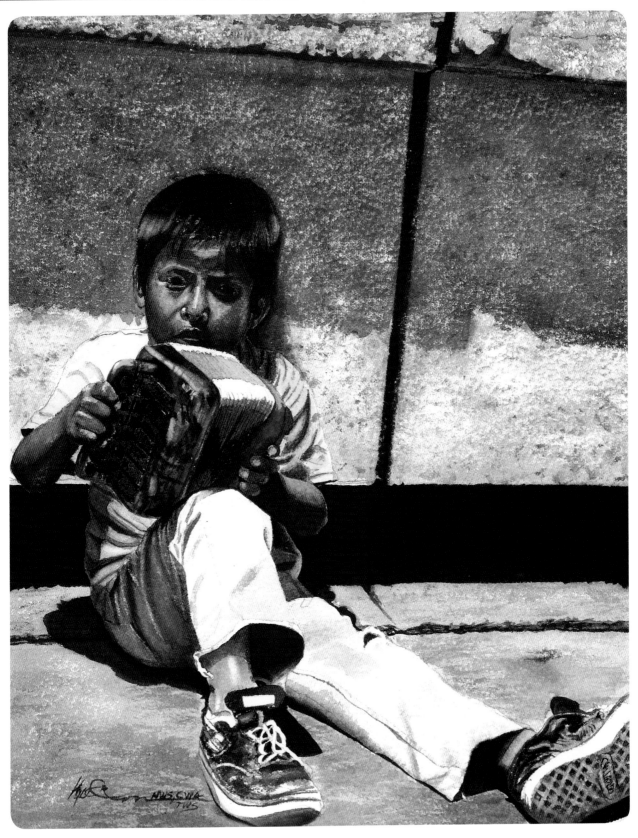

PERSISTENCE
watercolor on 300-lb. (640gsm) cold-pressed paper
13" × 10" (33cm × 25cm)

MATERIALS

SURFACE
300-lb. (640gsm) cold-pressed paper

BRUSHES
Nos. 1, 4, 5, 6, 8 sable rounds

No. 4 synthetic round

PIGMENTS
Alizarin Crimson

Burnt Sienna

Burnt Umber

Cadmium Yellow

Cobalt Blue

French Ultramarine

Ivory Black

Payne's Gray

Viridian

OTHER SUPPLIES
3B pencil

Cotton swab

Kneaded eraser

Masking fluid

Rubber cement pickup

Painting the elderly has always been exciting for me. I have always felt that when you photograph elderly people you get the natural person, no pretense, no phoniness; what you see is what you get. That is my whole premise for painting people—people being natural, going about their everyday tasks. That take-it-or-leave-it look. The elderly seem to present that childlike aura. Capturing the lines and textures of the skin of the elderly has always been a fascination of mine as well as gestures and movements. The advantage of the camera is that once you've captured that special look, you have always got it.

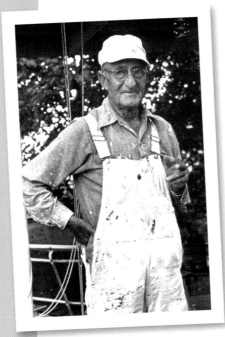

REFERENCE PHOTO
This photograph was taken many years ago in black and white. The challenge is to render it in color—remembering the color of the gentleman's clothing as well as his surroundings. We'll make sure to capture the soil and paint on his clothing as accurately as possible.

1 DRAW A PRELIMINARY SKETCH
Draw the basic foundation of the painting to show facial features, hands, clothing, the man's hat, the folds in his clothing and even his eyeglasses. Suggest background shadows and highlights.

2 APPLY MASKING FLUID

Since the background of this painting has so many highlights, we'll mask them out now. Apply masking fluid with a no. 4 synthetic round to areas in the background to suggest the dappled light of trees and other foliage. Lighten the heavier pencil lines with a kneaded eraser now, too.

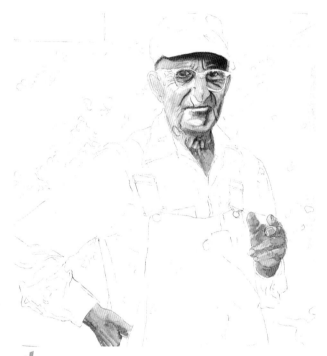

3 ESTABLISH FORM AND TONAL VALUES

Wash on a pale skin mixture of Alizarin Crimson, Cadmium Yellow and a small amount of Cobalt Blue using a no. 6 sable round. When dry, begin establishing the tonal relationships in the head, neck and hands by adding more color to the initial wash to make a richer color. Apply this denser tone to the areas of the old man's head, neck and hands with a no. 6 sable round. Rinse the brush in clean water and soften the edges of these areas so they blend into the initial wash.

4 DEFINE THE HEAD AND HANDS

When the head, neck and hands are completely dry, add the final washes. Mix a dark Burnt Sienna wash and with a no. 1 sable round paint in the lines around the mouth, eyes, forehead and nose, especially in the area of the neck. This will enhance the look of aging. Add a little French Ultramarine to this mix and brush in the shadow on the forehead directly under the bill of the man's hat to darken that area. Add the same wash to the right side of the face and under the chin, and to the back of the hands to bring out the form and detail. Use a lighter mixture for the inside of his left hand.

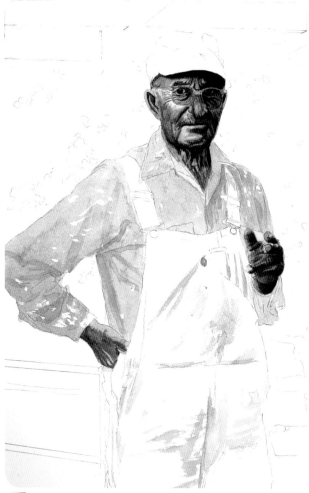

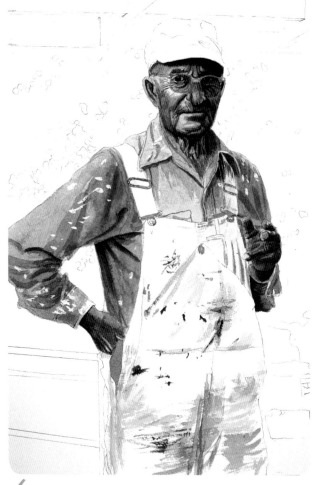

5 FINISH THE SKIN AND START ON THE CLOTHES

Continue to apply darker washes to the head and hands with a pale mixture of Cobalt Blue, French Ultramarine and a small amount of Alizarin Crimson. The darker washes will strengthen the form, as well as add character with the lines around the eyes, nose, mouth, neck and hands.

Add masking fluid with a no. 4 synthetic round to places on the shirt to represent paint splotches. When dry, paint the shirt with a French Ultramarine/Alizarin Crimson mix using a no. 8 sable round. When dry, block in shadows on the shirt and coveralls with a darker version of the shirt mix.

6 DEVELOP THE CLOTHING

Add a little more French Ultramarine and Alizarin Crimson to the initial mixture to darken it for painting the folds, shadow areas and seams in the man's shirt. At this point, you need only to establish those areas with the darker tones; the edges can be blended more later. Wait for the wash to dry completely before applying another layer. Make a slightly darker mixture of French Ultramarine, Alizarin Crimson and Payne's Gray for the dark areas in the coveralls and the shadow side or right side. Do not smooth edges yet. The last applications are to represent soil, smears of dried paint, folds and shadows.

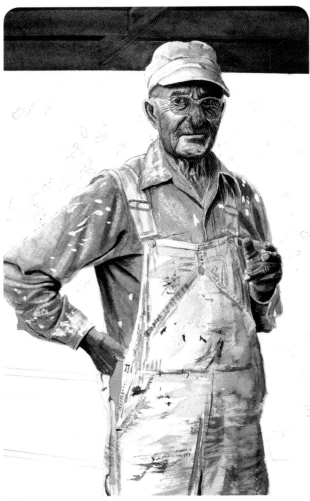

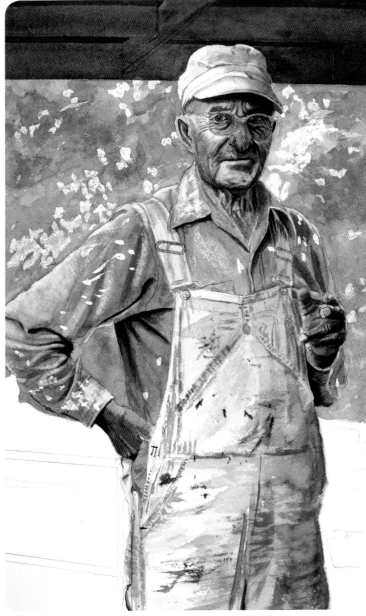

7 DEEPEN VALUES

With a much darker mixture of the initial mixture for the man's shirt, deepen the shadows in the folds of the shirt, underneath the collars and in the folds under his right arm. Use a no. 1 sable round to draw in the seams and stitching of the shirt. Darken the coveralls with a darker mixture of the original color and let dry. Paint the shadows of the old man's hat with a mixture of Cobalt Blue, Alizarin Crimson and a small amount of Payne's Gray. Prepare a pale to medium-dark mixture of Burnt Umber, Alizarin Crimson and French Ultramarine and apply the first layer to the porch roof over the man's head.

8 PAY ATTENTION TO DETAIL

It's now time to start painting in the background and continue working on the porch roof. You have already established the porch roof with the wash; now begin painting the detail using a damp no. 4 or 5 sable round to lift out the color in the edges of the joists to indicate reflected light. Darken the flat boards to indicate those farthest away from the light. Darken and lighten other areas of the porch roof as necessary.

Mix Viridian, Cadmium Yellow and Cerulean Blue or Cobalt Blue for the foliage in the background, and apply it carefully around the figure.

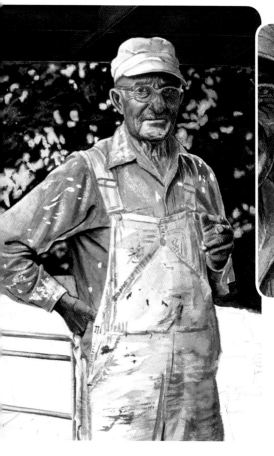

9 APPLY DETAILS TO THE BACKGROUND

Add Ivory Black to the greenish yellow foliage mixture so it becomes a very dark green. Apply this wash very carefully around the figure in the foliage area and trees in the background. Let it dry completely. After the wash has dried, remove the dried masking fluid with a rubber cement pickup. Use a cotton swab to start lifting out color in areas to give the appearance of the sky through open spaces in the leaves. Keep the edges of these areas very soft in appearance because they are in the distant background. Use a cotton swab to lift out color in the dark area to show changing values of the leaves.

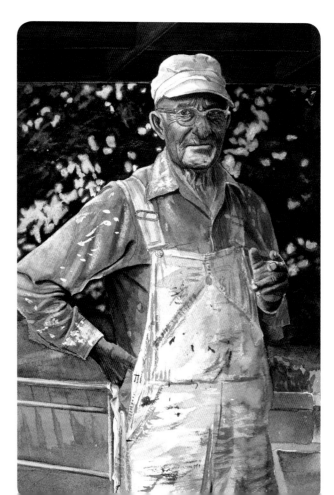

10 PULL IT TOGETHER

Mix a diluted wash of Burnt Umber, Alizarin Crimson and French Ultramarine to finish the bottom half of the painting. Don't be concerned about the detail, it can be nondescript backyard "junk"—boxes, old chair, large planter, old table, etc. Just paint shapes and don't spend too much time on them.

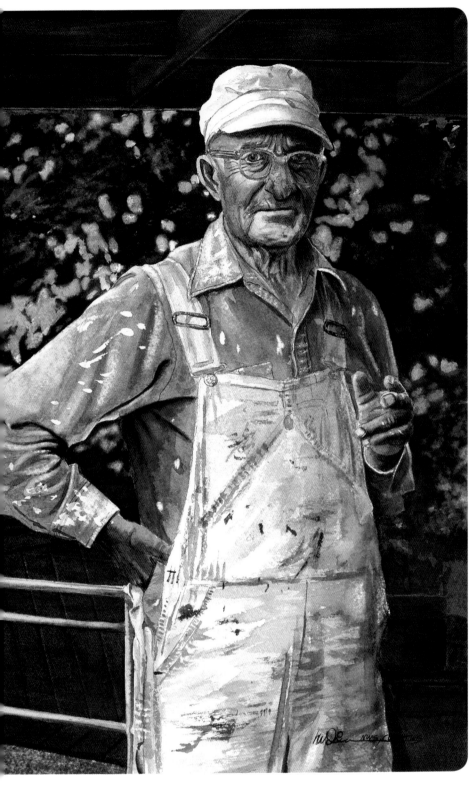

11 ADD FINISHING TOUCHES

When the painting is completely dry, add the final touches. Mix a dark wash of Burnt Sienna, a small amount of Alizarin Crimson, Yellow Ochre and Ivory Black. With a no. 6 sable round, darken and subdue the lower half of the background (everything in the backyard), keeping the edges very soft to appear out of focus, as in a photograph. Let this dry completely and darken further as necessary to give the figure prominence within the composition. Survey the entire painting, strengthening details, adding details and darkening shadows where necessary.

OLD MAN IN COVERALLS
watercolor on 300-lb. (640gsm) cold-pressed paper
18" × 12" (46cm × 30cm)

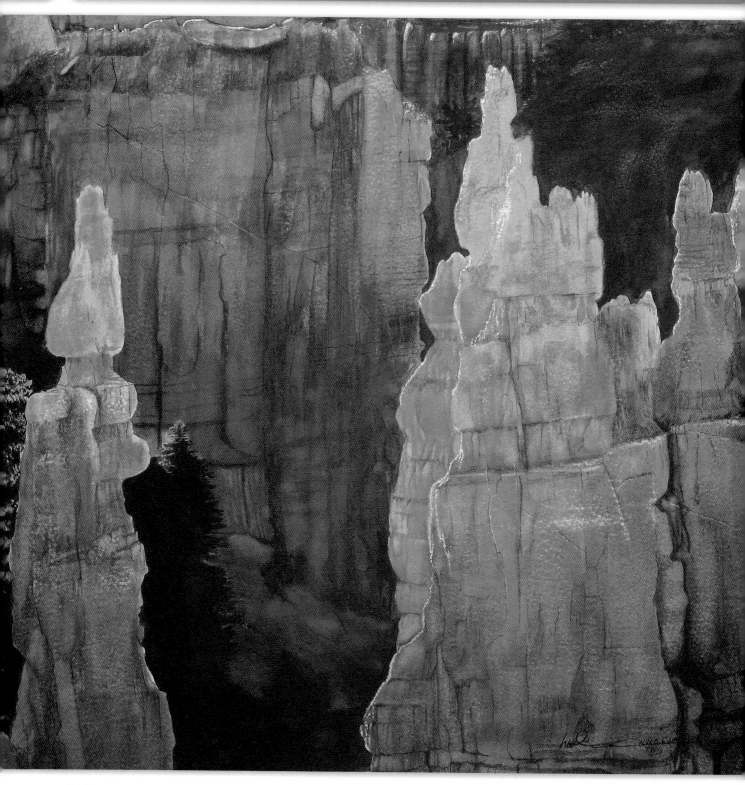

HOODOOS
watercolor on 300-lb. (640gsm) cold-pressed paper
16" × 27" (41cm × 69cm)

PART 2

PLACES

Painting places (in essence, painting landscapes) means a lot of different things to a lot of different artists. For me, it means terrains that offer, in many ways, dramatic changes in their appearance by way of tonal values, lighting, shadows, color temperatures and mood. These dramatic changes seem to take place every hour, even every minute, which is why photographing these locations really comes in handy.

One of the keys to making successful landscape paintings from photographs is to be creative and not allow the photos to dictate what you paint. Just choose your landscape carefully ahead of time and be quite sure you can live with the final results.

MATERIALS

SURFACE
300-lb. (640gsm) cold-pressed paper

BRUSHES
No. 3 synthetic round

Nos. 4 and 6 sable rounds

PIGMENTS
Alizarin Crimson

Burnt Sienna

Cadmium Red

Cerulean Blue

French Ultramarine

Ivory Black

Payne's Gray

Yellow Ochre

OTHER SUPPLIES
220-grit sandpaper

3B pencil

Craft knife with no. 616 blade

Masking fluid

Rubber cement pickup

Watercolor is particularly well suited to architectural subjects. You can lay broad flat washes of one color or a deliberately uneven wash to suggest the slightly irregular surface on old buildings. You can make clean crisp edges and define decorative details with a small sable brush.

This particular building intrigued me because of the intricate ironwork in the balcony and the large, detailed windows.

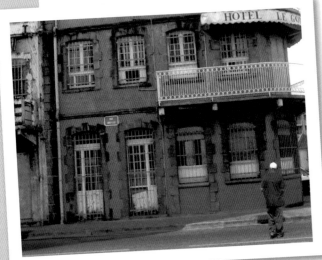

REFERENCE PHOTO

I photographed the building straight on instead of at an angle because I wanted to take full advantage of the intricate detail on the façade. The figure in the foreground is my youngest son. Adding him in the composition will give the painting some life.

1 ESTABLISH THE IMAGE
From the onset, the painting should be detailed and controlled. Draw the buildings with a 3B pencil to develop an accurate guideline for the color. Define the many complex shapes affixed to the building's exterior, and define the shadows. Add in the figure.

2 PRESERVE WITH MASKING FLUID

Preserve the window and door bars and the balcony rail from paint until the final step. Trying to paint around and between the bars and balcony rail could be quite challenging, so apply masking fluid to these areas instead using a no. 3 synthetic round. Mask the pipe running down the center of the building as well.

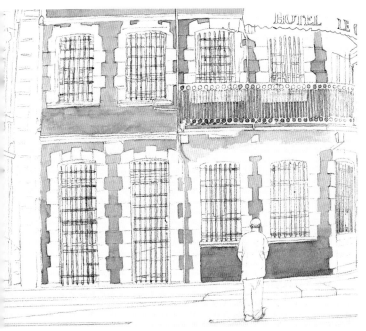

3 ESTABLISH COLOR TEMPERATURE

Paint a pale mix of Alizarin Crimson, Yellow Ochre and French Ultramarine on the front façade of the building with a no. 6 sable round. Make sure the stone window and door treatment of the building are kept clean and untouched from any paint.

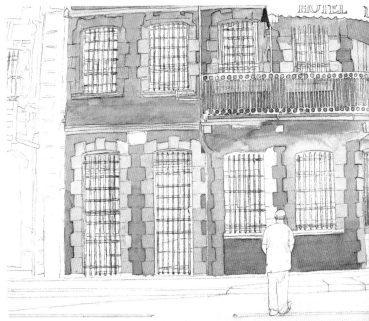

4 ADD TONE TO THE WINDOW/DOOR TREATMENT

Paint the stonework around the windows and doors with a medium-range mix of Payne's Gray and a small amount of Ivory Black using a no. 4 sable round. The two colors will give the building a warm/cool contrast.

5 STRENGTHEN DEPTH OF TONE

Add a deeper, richer tone to the stucco-like façade of the structure with a no. 6 sable round by strengthening the already mixed color for the building and applying it over the medium hue.

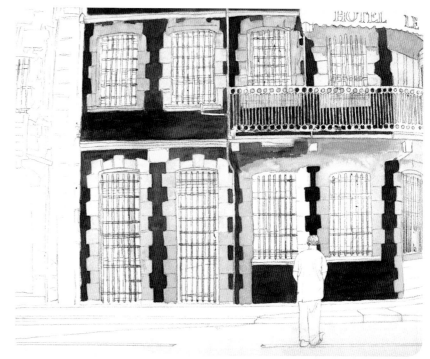

6 BRING OUT THE TRIM

Mix Payne's Gray, Alizarin Crimson and Ivory Black to paint the final tone of the stonework trim with your no. 6 sable round.

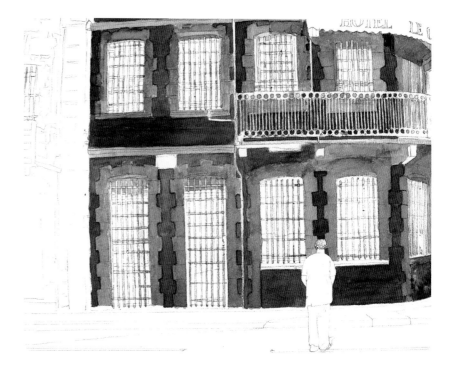

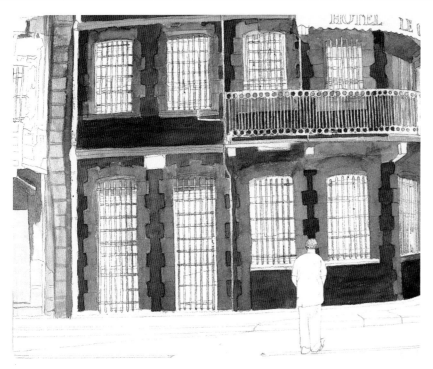

7 START THE SECONDARY BUILDING

Apply a mixture of French Ultramarine, Ivory Black and a very small amount of Alizarin Crimson on the building to the left of the central building with a no. 4 sable round. These stones are of a cooler hue than the ones around the doors and windows of the central building.

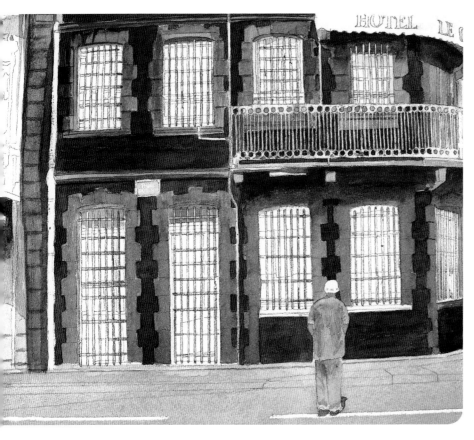

8 ADD SOME LIFE

Use your no. 6 sable round and a mix of Alizarin Crimson, Yellow Ochre, Burnt Sienna and a small amount of Cerulean Blue for the skin tone of the African-American figure in the foreground. For his shirt, mix Payne's Gray and Cadmium Red. Incorporate French Ultramarine for the trousers. Use the white of the paper for the hat or apply masking fluid to the hat area. Add a short shadow in front of his feet to represent the noonday sun. For the street and sidewalk, mix Yellow Ochre, Cerulean Blue and a touch of Alizarin Crimson, being careful to paint outside the white lines in the street.

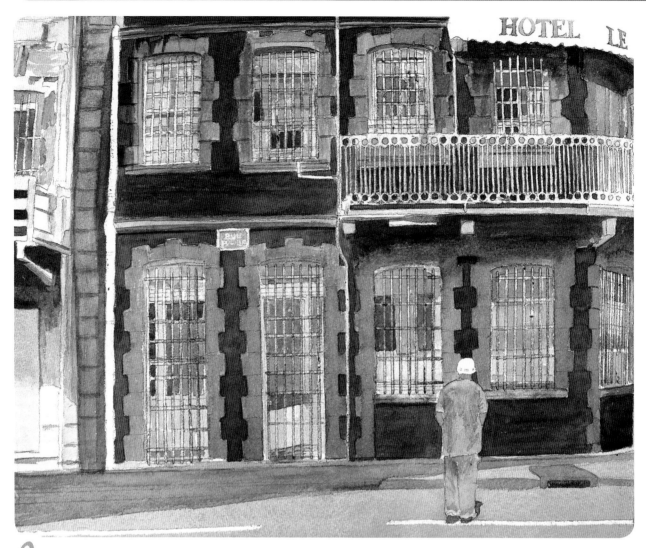

9 ADD DETAILS TO THE WINDOWS AND DOORS

Use a no. 4 sable round to lightly block in the detail behind the bars of the doors and windows (the windowpane dividers, the open windows, the broken windows, etc.) with Payne's Gray for the darker areas, a mix of Ivory Black and Cerulean Blue for the midrange grays and a mix of Alizarin Crimson and Payne's Gray for the midrange reddish reflections. Be careful not to rub away the masking fluid applied at the beginning.

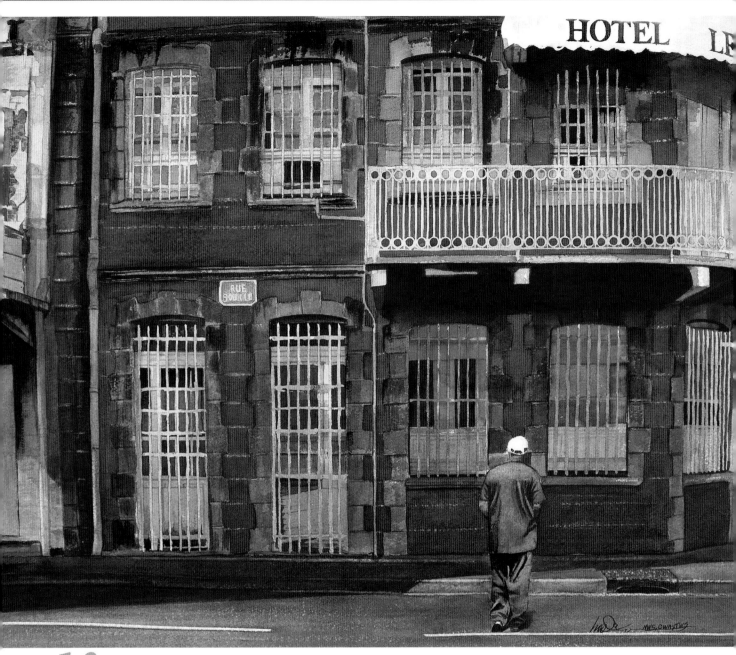

10 FINALIZE THE PAINTING

In this final step, every area of the painting should be evaluated, checking the values and accuracy to the photo.

Clarify the different values of each window and door behind the bars, using a no 4. sable round and additional layers of the mixtures in step 9. Add a mixture of Ivory Black, Cerulean Blue and some Yellow Ochre to the window on the upper left to suggest a light on in the room.

Strengthen the color and detail on the façade of each building. Add a darker version of the Payne's Gray mix to the stone areas with a no. 4 round. Create dramatic shadows under the porches and awning. Use 220-grit sandpaper and rub lightly to give a concrete-like texture to the street, sidewalk and stone areas. Use a craft knife horizontally across the red wall areas to suggest bricks.

Finally, carefully remove the masking fluid with a rubber cement pickup to add the final paint to the bars. Paint the bars with a variety of values made from a mix of Payne's Gray, Cerulean Blue and Ivory Black.

ABANDONED
watercolor on 300-lb. (640gsm) cold-pressed paper
18" × 22" (46cm × 56cm)

RURAL LOCATIONS

MATERIALS

SURFACE
300-lb. (640gsm) cold-pressed paper

BRUSHES
Nos. 2, 3, 4, 6, 10, 12 sable rounds

No. 4 synthetic round

PIGMENTS
Alizarin Crimson

Burnt Sienna

Burnt Umber

Cadmium Orange

Cadmium Yellow

Cerulean Blue

French Ultramarine

Ivory Black

Payne's Gray

Viridian

Winsor Green (Yellow Shade)

Winsor Yellow

Yellow Ochre

OTHER SUPPLIES
3B pencil

Masking fluid

Rubber cement pickup

Many artists are drawn to paint landscapes such as this rural autumn scene; the brilliant colors, rustic houses and country road certainly are tempting. I'm not generally a painter of trees, but I have to admit I was thoroughly inspired by this photograph of the faded siding on the two-story house and the vivid colors of the trees against the deep azure blue of the sky. And you have to wonder where that lonely road will end up as it fades away back in the distant trees.

REFERENCE PHOTO
Photographs like this one have always been tempting to paint in watercolor. Until now I have resisted as I have always felt insecure about painting foliage. But this time I'm glad I took the leap.

1 POSITION THE IMAGE
Transfer the composition from the photograph to your choice of watercolor paper. I omitted a few trees from the side of the house to simplify the composition and create a stronger design. Use a 3B pencil to develop an accurate guideline for the washes and to ensure that the lines can be easily erased when necessary.

2 ESTABLISH THE COLOR PARAMETERS

Use a no. 6 sable round to apply a light wash of Yellow Ochre to both sides of the two houses and a light mixture of French Ultramarine and Alizarin Crimson to establish the rooflines of the houses.

3 ADD COLOR TO THE SKY

Add a light mixture of Cerulean Blue and a small amount of Alizarin Crimson to the sky area with a no. 10 or no. 12 sable round, leaving small areas of the paper white to represent the whitest part of the clouds and wherever the trees will appear.

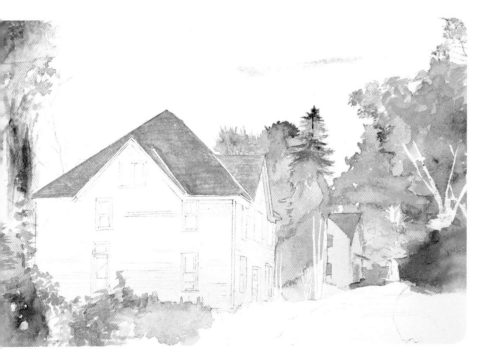

4 ADD COLOR TO THE TREES AND FOLIAGE

Let the sky fully dry. Then use a no. 10 sable round to block in the trees and ground foliage using general shapes. For the trees, branches and leaves on the left side of and bottom of the house, use a light value of Winsor Green, Viridian and Cadmium Yellow. Use a light combination of Burnt Sienna and Viridian for the top left corner of the picture. For the orange autumn trees in the background, use a light mix of Cadmium Orange and Cadmium Yellow. For the evergreen tree, use a mix of Winsor Green and Burnt Umber. For the trees on the extreme right, use the same mixture as used for the upper left corner. Add Burnt Sienna and Burnt Umber to soften the brightness of the Winsor Green mix as needed.

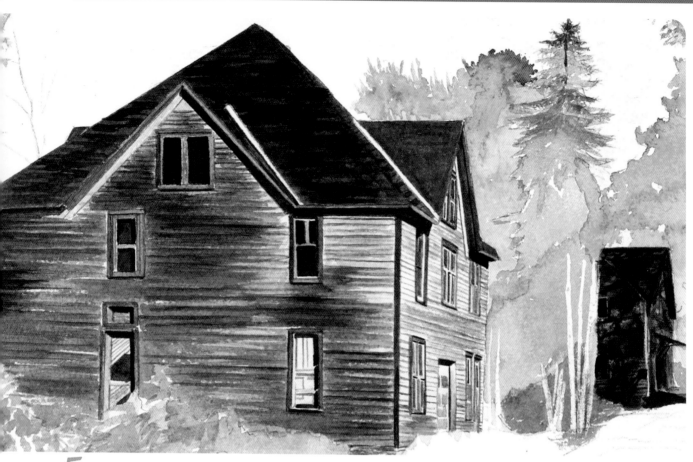

5 DETAIL THE HOUSES

Mix Yellow Ochre and Burnt Umber and blend warm and cool hues using flat washes with your no. 6 sable round on both the facing wall and the roadside wall of the foreground house. Use a slightly darker mix of Yellow Ochre and Burnt Umber to produce the faded section of the facing wall of the larger house. Use this same mix for the shadow underneath the house's siding. Apply a black mix (from Alizarin Crimson, Winsor Green and French Ultramarine) in the dark areas of the windows with the no. 6 sable round and a blend of Alizarin Crimson and Burnt Sienna for the window trim.

On the smaller house in the background, add a much darker mixture of the Yellow Ochre, Burnt Umber and Ivory Black that was used for the side and front, still using the no. 6 sable round. To bring out the dappled light from the trees on the sides of the background house, use a no. 3 damp sable round to lift out color, leaving the darker color to portray the shadow of the surrounding trees. Use a dark blend of French Ultramarine and Alizarin Crimson for the roofs showing a hint of asphalt shingles.

6 PAINT THE FOREGROUND TREES AND FOLIAGE

Mix Viridian and Cadmium Yellow to get a yellow-green hue, and use a no. 4 sable round to paint it into the area where there are bright green leaves. Let dry. This will act as an underpainting. Next, mix Winsor Green, Burnt Sienna and Ivory Black and paint this yellow-green over the wash you just applied. Apply masking fluid with a no. 4 synthetic round to the bright yellow leaves in the foreground to preserve their brightness. For the areas in the foreground trees and foliage that are brownish in hue, apply a mix of Burnt Sienna, a small amount of Yellow Ochre and a small amount of Ivory Black. Leave openings in the tree foliage to allow the blue of the sky to show through. For the green foliage in the lower center of the composition, use the same yellow-green wash as was underpainted in this area. Use a dark green mix of Winsor Green and a small amount of French Ultramarine to overlay the completely dried yellow-green wash. When dry, use a damp no. 3 or no. 4 sable round to lift out the dark green color to form the shape of the light green leaves and other foliage. In the brown areas, use the same brush to lift out the color to form the lighter brown twigs, stems and tree branches.

7 PAINT THE FALL FOLIAGE

Apply masking fluid to the tree trunks with a no. 4 synthetic round. Then use your no. 4 sable round to paint the basic shapes of the tree leaves in pale yellows, oranges and some bright greens. The bright yellow and the bright green leaves will be those areas that are lit by direct sunlight.

8 ADD LEAF DETAIL TO THE BACKGROUND TREES

Paint intermediate tones in various shapes and colors (dark and light greens) throughout the tree on the far right, defining the shapes with a no. 4 sable round. Strengthen some of the yellows and oranges, and add Burnt Sienna and Burnt Umber for shading. Apply washes of deeper tones (mixing Viridian and Ivory Black) for depth and dark accents. Remove masking fluid from the tree trunks with a rubber cement pickup and drybrush shadows from the foliage onto the tree trunks and branches using a no. 4 sable round and a mixture of Viridian, French Ultramarine and Burnt Umber. When strengthening the shadow falling on the lower part of the trunks, fade edges softly. Paint the dark thin branches and twigs. Painting dark leaves in the background area of the tree gives added depth. Remove the masking fluid from the yellow leaves on the left side of the house and add a wash of Winsor Yellow with a no. 4 sable round.

9 ADD TO THE AFTERNOON SKY

Deepen the sky using a mix of Cerulean Blue with a small amount of Alizarin Crimson using your no. 4 sable round. Paint in the blue area to form the white cloud shapes and soften the edges.

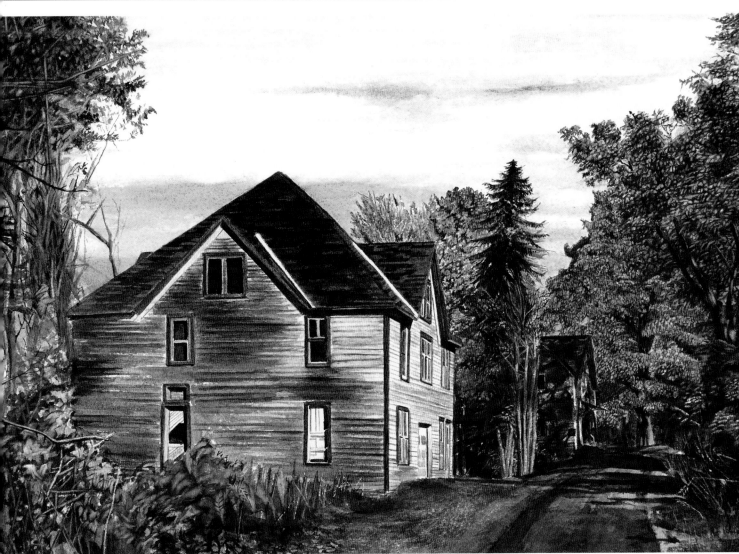

10 PAINT THE GROUND

Paint the ground area with a no. 4 sable round and a mix of Cadmium Orange, Winsor Green and Burnt Sienna on the left side of the road. Before you apply the wash, use masking fluid in areas of your choice to show fallen autumn leaves of bright oranges, yellows and greens. For the right side of the road or the side across from the houses, use a mix of Viridian, Burnt Umber, Winsor Yellow and Alizarin Crimson and let completely dry. Next, use the tip of a dampened no. 2 sable round and gently lift out streaks of tall grass. For the pavement, use your no. 4 sable round with a mix of Payne's Gray, Cerulean Blue and a small amount of Burnt Umber. For the shadows streaming across the road, use a Burnt Sienna/Payne's Gray mix.

A COUNTRY MILE
watercolor on 300-lb. (640gsm) cold-pressed paper
13" × 18" (53cm × 46cm)

MATERIALS

SURFACE
300-lb. (640gsm) cold-pressed paper

BRUSHES
Nos. 4, 6, 10 sable rounds

PIGMENTS
Alizarin Crimson

Burnt Sienna

Burnt Umber

Cerulean Blue

French Ultramarine

Permanent Rose

Winsor Green (Blue Shade)

Yellow Ochre

OTHER SUPPLIES
3B pencil

Painting a still life is always an excellent exercise. Certain things can be guaranteed. Painting rocks is no less of a challenge than painting a glass bottle or metal object, whether you are arranging rocks to set up your own composition or photographing a readymade composition on the side of a lake or in your backyard rock garden.

A common mistake is to think that if something is rough surfaced, angular and hard, it must be extreme in tone and value. In reality, if you look at a single rock in an average-lit situation outdoors through squinting eyes, you can begin to see all the subtle value changes.

REFERENCE PHOTO
The rocks in this photograph were piled and spread out along the shore of a lake not far from my home. The composition was already set up for me. It was just a matter of looking through my camera's viewfinder and panning over the rocks to find an exciting and dramatic composition to paint.

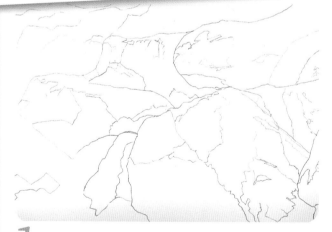

1 LAY THE FOUNDATION
Use a 3B pencil to transfer the image onto your watercolor paper. Manipulate the design of the rocks if you choose. Keep in mind that the rocks should be viewed as geometric shapes (squares, triangles, octagons, etc.), carefully noting the light and shadow planes. There is no need to paint every crack and spot, especially if they are in the far distance. Of course, the amount of detail painted is at your discretion.

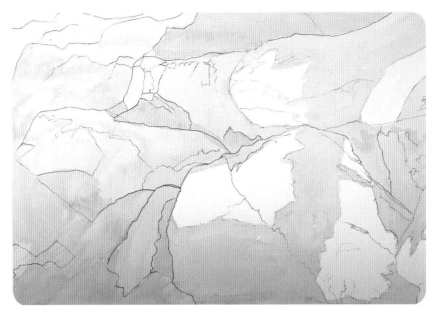

2 APPLY THE FIRST WASH

Mix a warm tone of Alizarin Crimson, Yellow Ochre and Cerulean Blue in plenty of water, and use a no. 10 sable round to apply it to everything except the lightest planes or surfaces of the rocks and let it completely dry. Now we have established the lights (the white paper) and the pale middle tones.

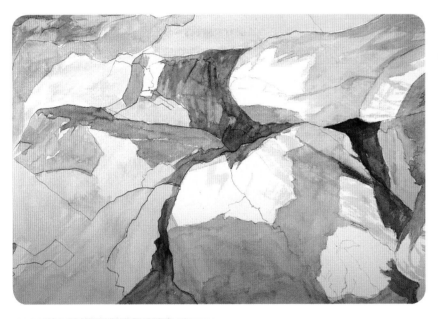

3 LOCATE THE MIDDLE TONES

Locate the darker middle tones by covering the areas with a second wash of the same mixture plus a small amount of French Ultramarine and brush as in step 2 over a completely dried first layer. Because these areas now contain two separate washes, they are twice as dark as the tone that covered the paper in the previous step. Let this wash dry.

Have Fun Painting Rocks

Painting rocks, especially in watercolor, offers many challenges, one being what technique to use to convey its rough surfaces. You can experiment with different objects and materials such as sponges (natural is better), dry brush and masking fluid, to name a few. Try painting rocks flooded with light and producing dramatic shadows. I think you will have fun; I do.

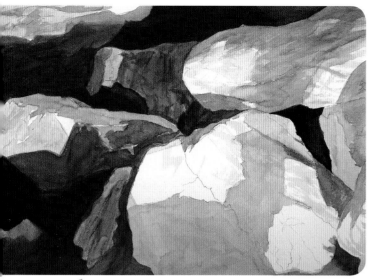 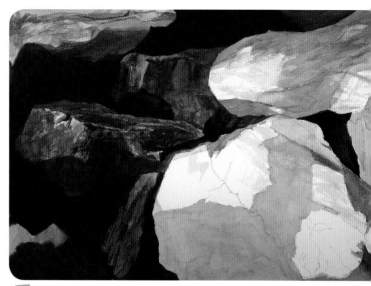

4 ADD SHADOW TONES AND COLOR

Mix a wash of French Ultramarine and Alizarin Crimson and wash in the darker shadow areas with the no. 10 sable round. Apply several layers of this, letting the paint dry completely between applications. To further darken the lighter shadows, use a middle-value mix of Cerulean Blue and Alizarin Crimson and apply this over the already dried application on the rocks in the middle-ground area.

5 DEFINE THE DETAILS IN THE MIDDLE GROUND

After you have given a general shape and form to the rocks in the middle ground and have established shadows, you are ready to introduce the details. Apply a mixture of French Ultramarine and Alizarin Crimson to the shadows on the rocks in the middle-ground area with your no. 6 sable round. For the sunlight on the middle-ground rocks, apply a mixture of Burnt Umber, Cerulean Blue and Yellow Ochre with a small amount of Permanent Rose for accents. These washes should be a midrange value. Since we want to keep this painting closely resembling the photograph, soften the edges so they appear slightly out of focus, relating to the depth of field for photography.

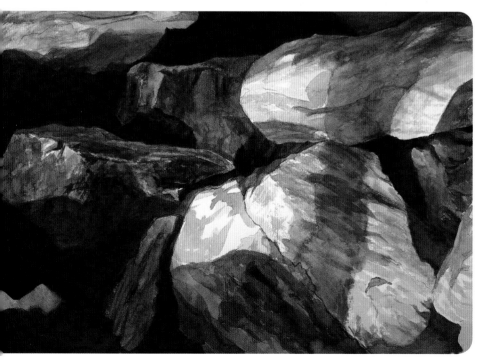

6 DEFINE THE DETAILS AND SHADOWS IN THE FOREGROUND

Use a dark mix of French Ultramarine and Burnt Sienna with a no. 4 sable round to add cracks, planes and other details to the rocks in the foreground. Use flat, general brushstrokes for positioning only; later on you will soften and add more detail.

The shadows should appear as a cool color while the sunlit areas are painted with a warmer color to show temperature contrasts.

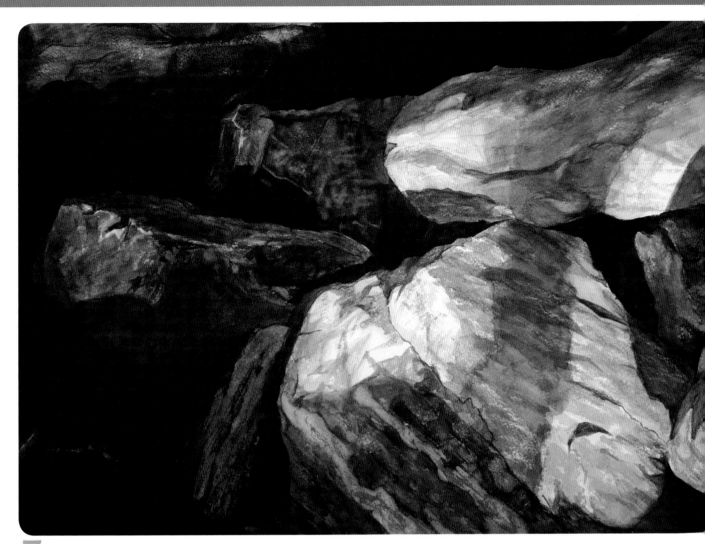

7 ADD THE FINISHING TOUCHES AND REFINE DETAILS

Complete the final brushstrokes of the painting using a dry-brush technique with a no. 4 sable round to emphasize the rough texture of the rocks. Use a mixture of Alizarin Crimson, Burnt Umber and Yellow Ochre for the background and middle ground, and a mixture of Yellow Ochre and Permanent Rose for the foreground and in the highlighted areas.

Then glaze the shadows on the rocks with a transparent mixture of French Ultramarine, Alizarin Crimson and a small amount of Yellow Ochre using the same brush. This fluid mixture sinks into the rough brush marks to produce a rocky texture. Accent the shadow on the rock in the background with darker strokes of the aforementioned blend. Use a dense mixture of French Ultramarine, Alizarin Crimson and Winsor Green for the darkest shadow areas surrounding the rocks. Paint as many layers as you think necessary. Allow each layer to dry thoroughly before adding the next.

ROCK PILE AT LONGVIEW
watercolor on 300-lb. (640gsm) cold-pressed paper
15" × 22" (38cm × 56cm)

CANYON VISTA

MATERIALS

SURFACE
300-lb. (640gsm) cold-pressed paper

BRUSHES
Nos. 4, 6, 8, 10 sable rounds

PIGMENTS
Alizarin Crimson

Cadmium Red

Cadmium Yellow

Cerulean Blue

Cobalt Blue

French Ultramarine

Payne's Gray

Permanent Rose

Winsor Violet

Yellow Ochre

OTHER SUPPLIES
2B or 3B pencil

200-grit sandpaper

While viewing this canyon I felt as though I was on the rim of the world. Nothing but tremendous space and raw, beautiful rock face before me. Golden tan cliffs dropped thousands of feet to a crimson slope that led to vermilion ledges and more bluffs.

There was no way to fully comprehend this place; it's just too big. I couldn't afford to ask myself, "When and where do I begin photographing?" I know that if I hesitated, I would still be there today. So I started shooting right then. My camera seemed to kick into overdrive. I thought at one point I saw smoke rising from the camera. I knew that no paintbrush, no photograph, no documentary was doing this place justice. I thought of the artist Thomas Moran's majestic and eye-popping masterpieces of this splendor of nature, and I asked myself, "What makes you think you can do this place any more justice?" Well, I'm going to have fun trying.

REFERENCE PHOTO
As I sifted through my reference photos of the canyon, I hesitated at this photo. This rock peak as it broke the early morning sun rays stood out like no other photograph.

1 ESTABLISH THE BASIC COMPOSITION
Use a 2B or 3B pencil to complete the initial drawing to establish the general planes, shadows and canyon layers as well as the horizon or skyline.

2 ESTABLISH THE SKY COLOR

Wash a pale mix of Cobalt Blue, Cerulean Blue and plenty of water in even strokes across the width of the sky area with a no. 10 sable round, overlapping each stroke to ensure a continuous, even application. Continue the wash past the horizon line of the canyon and allow to dry thoroughly. Add more color to the same mixture for a more concentrated blend and apply over the already dry first layer. Mix a small amount of Permanent Rose to the water and add a small light streak about halfway down the sky area.

3 STRENGTHEN THE SKY

Enhance the sky further by mixing a more concentrated version of the colors in step 2 and washing these over the dried second layer.

4 START ON THE BACK WALL

To prepare the distant back wall for detailing, mix a mid-value of Permanent Rose, Cobalt Blue and a small amount of Payne's Gray. Apply to the area with a no. 8 sable round. Let this dry completely.

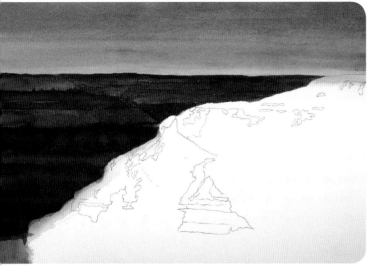

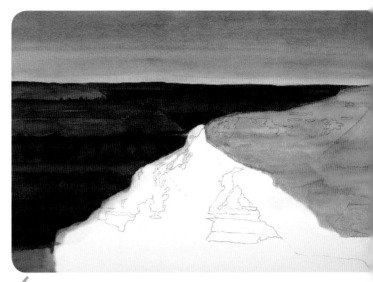

5 START THE LEFT SIDE MIDDLE CANYON WALL
Paint this middle canyon wall using a no. 8 sable round with a mix of Alizarin Crimson, Cadmium Red and French Ultramarine. Let dry. Then mix a darker version of the same color and apply this to alternating bands on the wall to produce the layered effect commonly seen in canyon walls.

6 BEGIN THE RIGHT SIDE MIDDLE WALL
Prepare a midvalue mix of Permanent Rose and Yellow Ochre as a base color. Apply with a no. 8 sable round and allow to completely dry, then add a second layer. Keep in mind that all the applications to this point are base layers, and the detailing will be incorporated later.

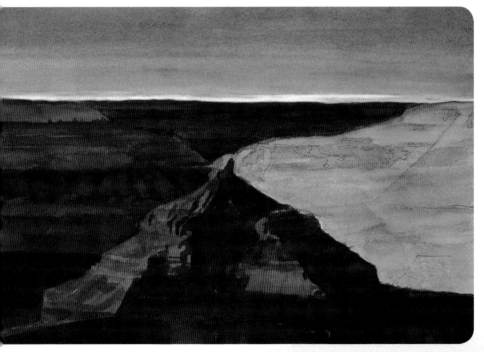

7 STRUCTURE THE FOREGROUND ROCK FORMATION
Wash on a mix of Cadmium Red, Cadmium Yellow and Permanent Rose with the no. 8 sable round for the bright orange of the sunlit rock face, and a mixture of Permanent Rose, Yellow Ochre and Winsor Violet with a touch of Payne's Gray for the deep shadows on the formation.

Scaling Your Subject

You can create the illusion of size and space by using layers of subordinate shapes and patterns in your painting, all respecting the dynamics of the rectangular space, horizontal or vertical.

Although the actual size of your painting's surface is not the issue, putting scale into a small painting requires a lot of control. In very small panoramic paintings, it may be only the range of detail that gives the effect of scale.

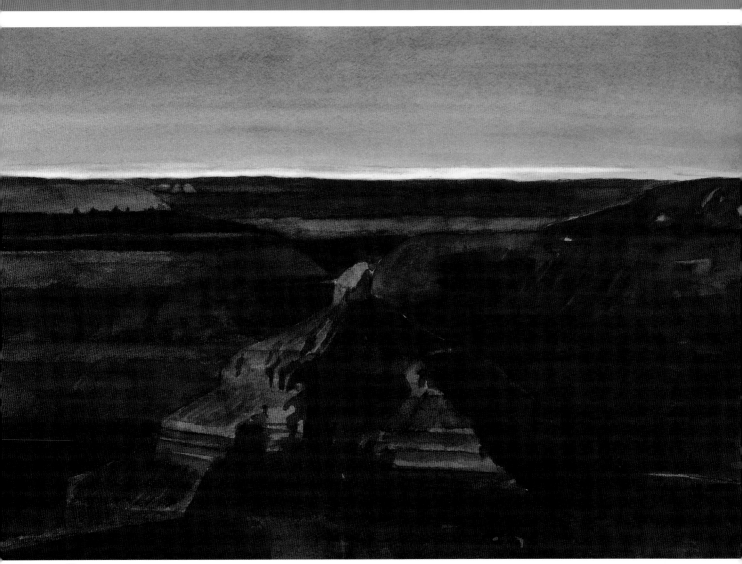

8 DEVELOP THE RIGHT MIDDLE WALL

Paint in the right side middle wall of the canyon with a fairly dark blend of Permanent Rose, Alizarin Crimson, Cadmium Red and French Ultramarine using a no. 6 sable round. Before it completely dries, apply streaks of Permanent Rose and Winsor Violet to represent the layers of bright colors for which the Grand Canyon is famous.

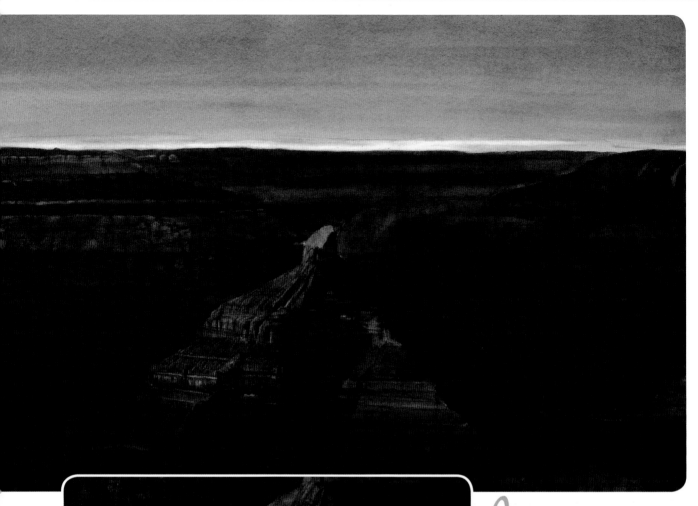

9 ADD DETAIL TO THE WALLS
Use a no. 4 and no. 6 sable round to strategically lift out color on the foreground rock formation.

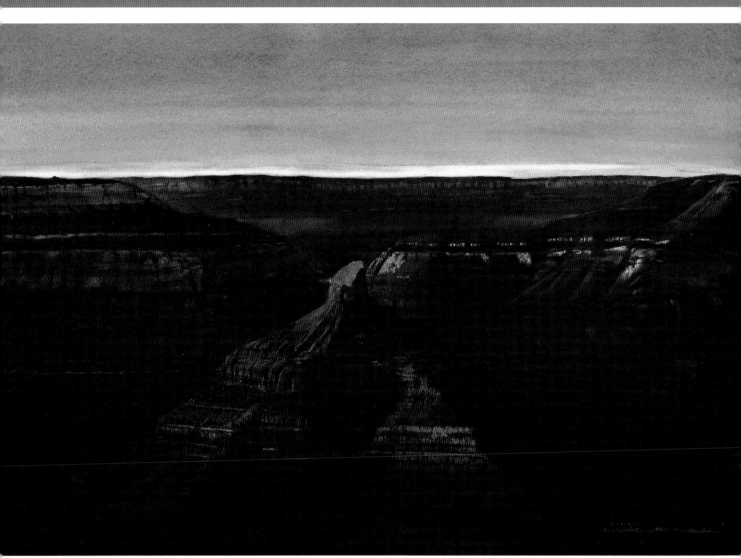

10 BRING OUT THE FINAL HIGHLIGHTS

Continue to lift out color as you did in step 9, bringing out the intricate details and highlights on the rocks and softening some of the hard edges. Where to lift out and how much to lift out are at your discretion. Lifting out color with the soft hair of a sable brush will cause much less damage to the paper's surface than any other tool. Use sandpaper for added texture if needed once the paint has dried.

FIRST LIGHT—GRAND CANYON
watercolor on 300-lb. (640gsm) cold-pressed paper
14" × 21" (36cm × 53cm)

MOUNTAIN SCENE

MATERIALS

SURFACE

300-lb. (640gsm) cold-pressed paper

BRUSHES

1-inch (25mm) flat

Nos. 3, 4, 6, 8 sable rounds

PIGMENTS

Alizarin Crimson

Burnt Umber

Cerulean Blue

French Ultramarine

Payne's Gray

Permanent Rose

Yellow Ochre

OTHER SUPPLIES

3B pencil

Cloth

Craft knife with no. 616 blade

Sand-colored pastel stick

Tips for Painting Dramatic Mountains

» Create a dynamic composition with two or three shapes at most.

» Focus on the dark and light patterns within the rocky face.

» Simplify the composition—don't paint every line or crack; it gives the viewer too much to look at, thus losing the effect of being imposing.

It seems as though mountains are nature's way of canceling out monotony across this world's land mass. Mountain ranges, whether all rocky or tree-lined, present an awesomeness that's difficult to explain. My enjoyment comes from the rocky side. Rocky mountain surfaces present an almost overwhelming presence. They offer challenges that no other subject can begin to offer.

REFERENCE PHOTO

When trying to visualize and compose a complex and busy photograph like this, I try to imagine the subject as a group of simplified geometric shapes; the sky and the foreground afford a place in which to organize those shapes.

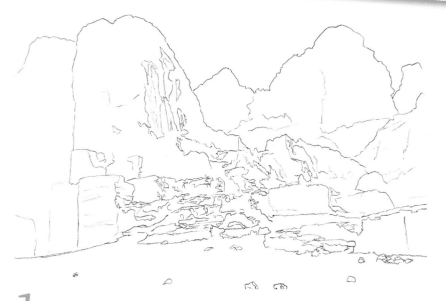

1 **DEFINE THE SHAPES AND SHADOWS**
Draw the peaks and complicated light patterns and shadows that will appear in later steps.

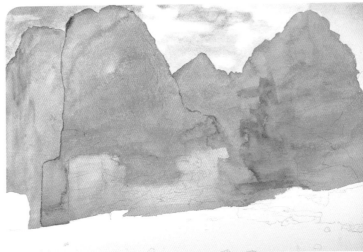

2 START WITH THE SKY

Paint the sky and clouds in roughly with a pale mix of Cerulean Blue and a small amount of Alizarin Crimson using a no. 8 sable round. Keeping the mixture pale allows the outline of the mountain peaks to show through to finish up later. Overlap the peaks with the blue wash so when the mountains peaks are painted the edge of the blue will not show. Leave the white of the paper to show cloud placement.

3 REFINE THE SKY AND ADD THE MOUNTAINS

Once the sky dries, add another wash of the same mixture, being careful to refine the clouds as well as keep the cloud edges very soft. Then mix and wash in the mountains and foothills using a no. 6 sable round with a medium-range mix of Burnt Umber, French Ultramarine and Alizarin Crimson. Let this dry thoroughly.

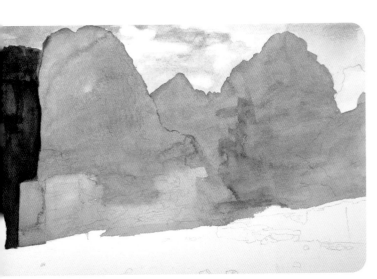

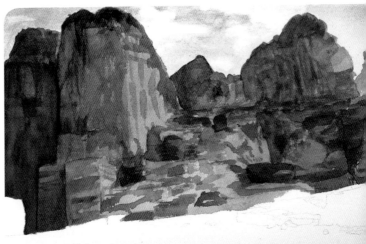

4 INTERPRET THE SHADY SIDE

Paint the left shadow area to establish it as the darkest part of the mountain scene. For this area, mix a dark blend of Burnt Umber, French Ultramarine, Permanent Rose and a small amount of Payne's Gray and use a no. 8 sable round.

5 BLOCK IN LIGHT, SHADOWS AND PLANES

Paint in the mountain peaks and foothills area using a no. 6 sable round with a slightly darker version of the mixture in step 4, adding the shadows and the different planes of the mountain. After the first wash has dried, add another layer to some of the darker shadows and planes to strengthen those areas.

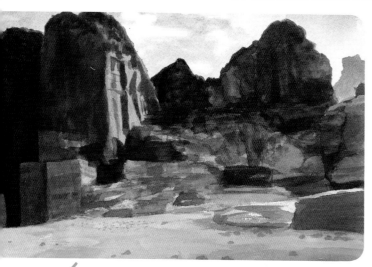 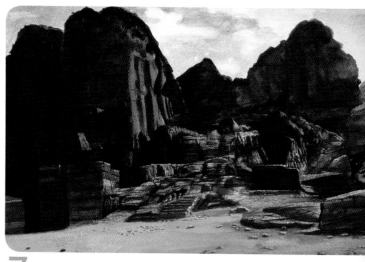

6 ADD THE FOREGROUND AND STRENGTHEN THE MOUNTAINS

Now it's time to start simplifying some of the more dominant areas of the painting before going on to the final details. Add strong shadows to the larger rock formations with square strokes using a 1-inch (25mm) flat soft-hair brush and a dark mixture of Alizarin Crimson, French Ultramarine and a little water. Use the point of a no. 3 sable round to draw some crisp lines over the surfaces of the rocks to suggest cracks and crevices. Use a no. 6 sable round with a pale mixture of Yellow Ochre and Permanent Rose for the sandy color in the foreground area, adding small shadows in the sand with a midvalue mix of Burnt Umber and Payne's Gray to represent pebbles and smaller rocks.

7 STRENGTHEN THE SHADOWS

Use a no. 4 sable round to add a darker mix of French Ultramarine, Alizarin Crimson and Burnt Umber in strategic areas to strengthen the shadows on the rock walls to give the sunlit areas more punch. Add more pinks and reds to some of the foreground rock formations to bring out their color.

Lay on more of the sand color from step 6 to the foreground to develop the shaded and sunlit areas. When this dries, rub over the entire foreground with the side of a sand-colored pastel stick, rubbing it in with a dry cloth. Then, lightly scrape out areas with a craft knife to represent pebbles and smaller rocks.

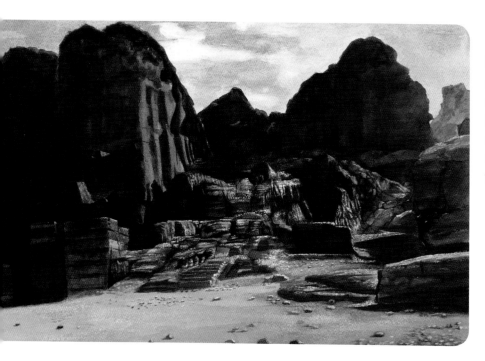

8 STRENGTHEN THE SKY

Make up a slightly stronger mixture of Cerulean Blue, a small amount of Alizarin Crimson and a small amount of water. Use a no. 8 sable round to paint over the existing dried layer of pale blue, giving the sky a more vivid blue in order to bring out the outline of the mountain peaks.

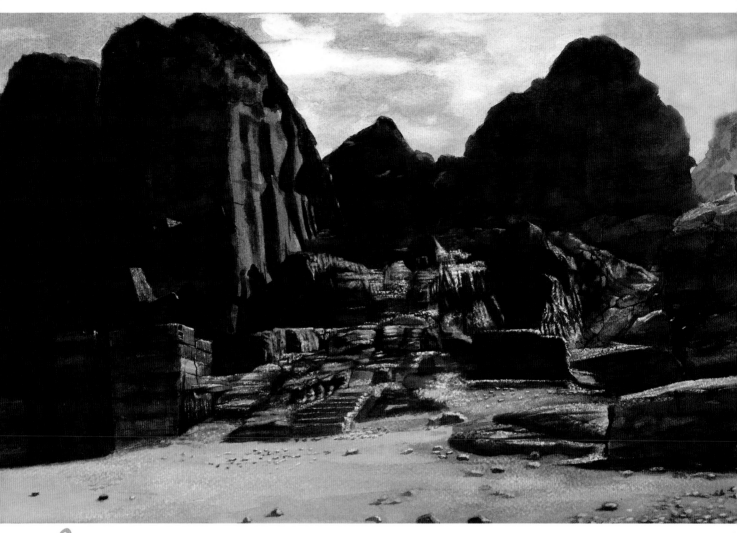

9 ADD ATMOSPHERE

Lightly rub a sand-colored pastel across the upper right sky area of the painting to add further interest and complete the realistic feeling.

MAJESTIC HORIZONS
watercolor on 300-lb. (640gsm) cold-pressed paper
13" × 21" (33cm × 53cm)

LAKES

MATERIALS

SURFACE
300-lb. (640gsm) cold-pressed paper

BRUSHES
Nos. 2, 4, 5, 8, 10 sable rounds

PIGMENTS
Alizarin Crimson

Burnt Umber

Cadmium Yellow

Cerulean Blue

Chinese White

Cobalt Blue

French Ultramarine

Payne's Gray

Permanent Rose

Viridian

OTHER SUPPLIES
2B or 3B pencil

Lakes are usually in some kind of motion, so you must observe and photograph the way the water looks at one instant and catch that look in the camera. A nice thing about moving water is that its movement is rhythmic; the sequence repeats so you can catch that fleeting movement again…and again…and again. As a general rule, simplify the movement and generalize the action. Paint some of the rocks, waves or splashes; don't try to incorporate them all.

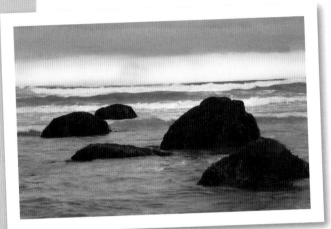

REFERENCE PHOTO
The rocks breaking up the space in this scene added to the drama of the composition and drew me in…not to mention the blues, purples, pinks and oranges of the sky.

1 FORMULATE THE BASIC COMPOSITION
Use a 2B or 3B pencil to establish the general planes and shapes (waves and on the rocks) within the composition. Place the horizon line high with all activity below it.

2 ESTABLISH COLOR WITH SKY AND CLOUDS

Mix Cadmium Yellow and Permanent Rose for a pale yellow-gold tint and apply in the sky area with a no. 10 sable round. Let this dry, then brush on a second application and allow it to dry.

3 ESTABLISH THE DARK CLOUDS

Mix a blend of French Ultramarine and Cobalt Blue to a medium value and apply this over the top half of the yellow-gold sky using a no. 8 sable round. Let this dry.

4 FINISH THE SKY

Finish the sunny or lower bright part of the sky with a slightly stronger version of the mix in step 2. For the dark clouds, use a blend of French Ultramarine and Cobalt Blue in a medium value. Apply to just over halfway down the sky area. Allow this to dry thoroughly and apply another layer; let that dry. The color or value should be fairly dark. Next, with a no. 4 sable round, start lifting out some of the color to form the cloud shapes. The cloud shapes can be your own design. They should be about half the value of the base or darker blue. Once the cloud shapes have dried, mix Permanent Rose and Cadmium Yellow and wash over the entire dark blue and cloud area. Soften all hard edges with a no. 4 sable round.

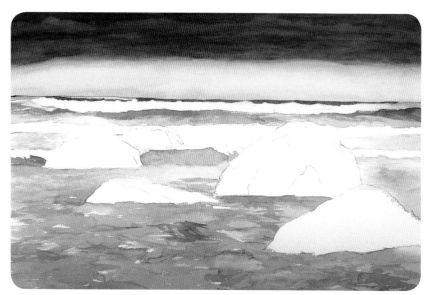

5 START THE WATER

Apply initial washes to the water with a no. 8 sable round and a pale mix of French Ultramarine, Cobalt Blue and a very small amount of Permanent Rose. Wash this over the entire lake area, being careful to paint around the rocks but slightly overlapping them.

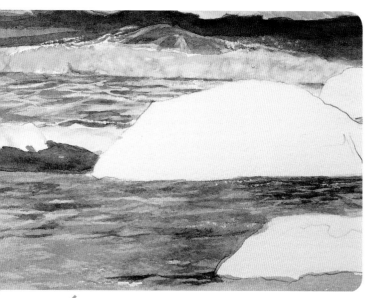

7 CONTINUE THE STROKES OF THE WATER

Use a no. 4 sable round and continue to work with short, and sometimes long, curved strokes in the immediate foreground using a dark mix of French Ultramarine, Cerulean Blue and Payne's Gray. These strokes shouldn't cover the foreground completely, but should leave gaps for the darker undertone to shine through. Finish painting the lake in this manner.

6 PAY ATTENTION TO DETAIL

Paint the tops of the background ripples with a no. 5 sable round to portray areas where the deep tones of the sky are reflected. This light tone is a mix of French Ultramarine and Permanent Rose with strokes of Chinese White. Carry this mix upward over the face of the oncoming wave to suggest the rolling motion of the wave. The ripples are short curves that you can see suggested in the background and middle-ground areas.

Because of the agitated surface action of crashing surf, there is little or no reflection. The rougher the water the darker its color, but lakes and oceans are usually darker than the sky above because of their depth.

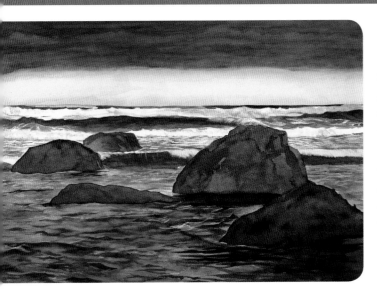

8 PAINT THE ROCKS

Apply a mix of Burnt Umber, Alizarin Crimson, and French Ultramarine to the rocks with a no. 5 sable round. While still a bit damp, apply a small amount of Permanent Rose and water on top of each rock. With this application you want to start showing some reflection of the sky on the rocks. Spread on a loose mixture of Viridian and Payne's Gray with a fair amount of water to show some signs of algae. Let dry completely. Continue to darken the rocks with the same mixture and brush, about two or three layers more. Allow each layer to dry between applications. Then add the rocks' shadows on the water with a mix of Burnt Umber, French Ultramarine, Alizarin Crimson and Payne's Gray, brushing this on with the same brush, using short, sweeping strokes. Add some Permanent Rose and Cadmium Yellow to show reflections from the sky.

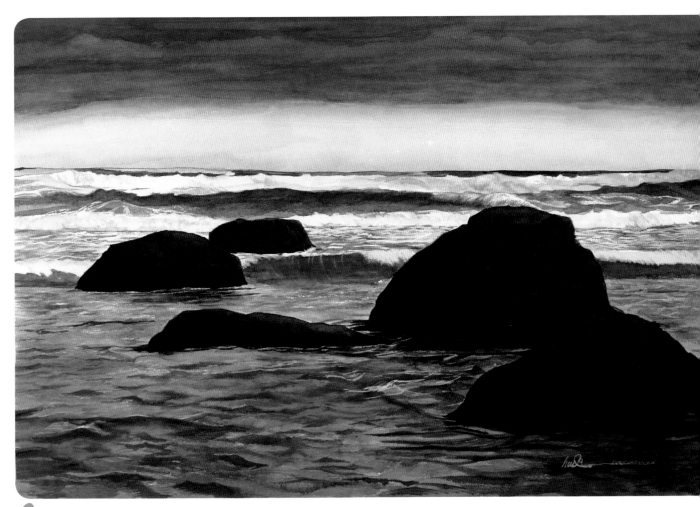

9 FINAL TOUCHES

To indicate the small waves splashing off the rocks, add Chinese White close to the bottom edge of the rocks with the pointed tip of your no. 2 sable round. Use a damp no. 4 sable round to lift out color from the corners of the rocks to indicate highlight as well as blend the color of the sky's reflections and the natural rock colors. Continue to smooth some edges of the wave strokes until you are pleased with the results.

A SERENE PLACE
watercolor on 300-lb. (640gsm) cold-pressed paper
15" × 23" (38cm × 58cm)

RIVERS

MATERIALS

SURFACE
300-lb. (640gsm) cold-pressed paper

BRUSHES
Nos. 2, 4, 6, 10, 12 sable rounds

PIGMENTS
Cadmium Red

Cadmium Yellow

Cerulean Blue

Cobalt Blue

French Ultramarine

Ivory Black

Payne's Gray

Permanent Rose

Winsor Blue (Green Shade)

OTHER SUPPLIES
3B pencil

Craft knife with no. 616 blade

We often hear people say how beautiful the colors of water are, but water has no color of its own. Water gets its color from its surroundings. An azure blue sky generally means azure blue water. A smaller body such as a river or pond will tend to take its colors from the shore and whatever is on the shore: foliage, buildings, etc. Taking photos to paint from will help, not just in harnessing the movement of the water, but in capturing the vast number of colors present in the water. In short, don't just decide the water is blue, gray or green. Look carefully and paint what you actually see.

REFERENCE PHOTO
It was hard to resist photographing this view of the river and these bridges. I was intrigued by the silhouette of the bridges crossing over the river, which took on the colors of the sky, clouds and sunset.

1 CREATE THE FOUNDATION

Use a 3B pencil to carefully draw the main elements of the composition: the two bridges, the foliage and buildings in the horizon, and the clouds. The river itself can be largely suggested as far as showing the ripples and waves.

2 INTRODUCE COLOR IN THE SKY

By mixing Winsor Blue (Green Shade), Cerulean Blue and Permanent Rose, you can closely produce the sky seen in the photo. Apply the wash around the cloud formations with a no. 10 or no. 12 sable round and allow to dry. Erase enough of the pencil lines so enough will remain that you can still see.

3 ADD IN THE CLOUD COVER

Apply a second layer of blue to the sky with the same mixture as in step 2 and allow to dry. The orange color in the clouds is the bright orange-colored sun reflected back onto the clouds. Create this orange with a mix of Cadmium Red and Cadmium Yellow using a no. 10 sable round. Paint the bluish color of the rain clouds with a Cerulean Blue, Cobalt Blue and Permanent Rose mix.

4 DEVELOP THE CLOUD FORMATIONS

Continue to paint the dark rain clouds with the same mix from step 3 using a no. 10 sable round. Apply a second wash over the first to get a darker value. The orange glow of the setting sun appears brighter as the clouds get darker. Try to leave as much of the pencil as you can for the bridges. If the lines of the bridges are fairly dark, it won't matter because of the dark value of the two bridges.

5 BUILD THE BRIDGES WITH VALUE

In this scene, the bridges over the river are but silhouettes of horizontal, angular and vertical steel crossbeams fading into the distance. Use your no. 6 sable round with a mix of Payne's Gray and French Ultramarine for the upper part of the bridge, and a Cerulean Blue, Ivory Black, Cadmium Red and Payne's Gray mix to paint the stone bridge supports.

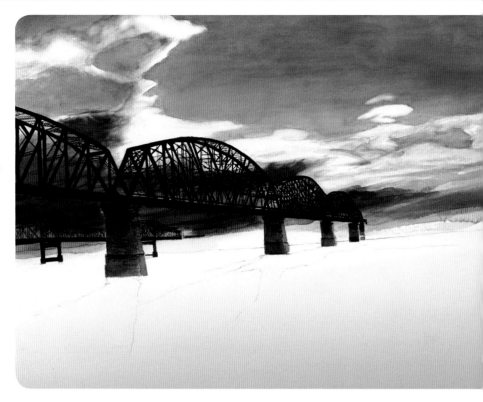

6 BUILD THE DISTANT LANDSCAPE

Add a slightly darker than medium wash of Payne's Gray for the first application of the distant landscape. Mix with water and wash on with a no. 6 sable round. Let dry.

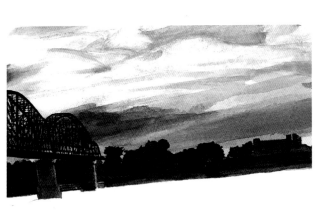

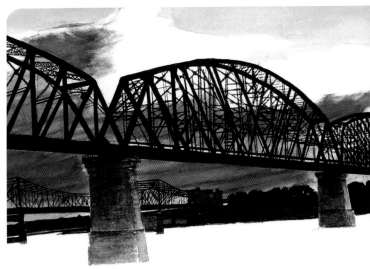

7 DEFINE THE DISTANT BUILDINGS AND FOLIAGE

With a much darker version of the mixture in step 6, begin painting in the detail of the strip of background landscape area. You can make it as detailed as you choose.

8 FINISH THE BRIDGE SUPPORTS

Finalize the bridge supports with a darker value mix of Payne's Gray, Cadmium Red and Cobalt Blue. Add suggestions of the stone masonry pattern by laying in horizontal strokes with your no. 2 sable round.

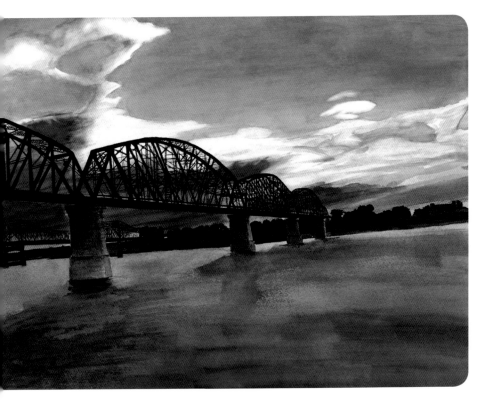

9 PAINT THE RIVER

The first stage of painting the river is to add in the shadows, reflections and the different colors. Apply the reflections of the sky first using a no. 4 sable round with a medium-value mix of Cadmium Red and Permanent Rose. Let this dry. Next, add a slightly darker than medium value blue mix of Cobalt Blue, Cerulean Blue and Payne's Gray. Use this wash to suggest the shadows of the bridge and its supports.

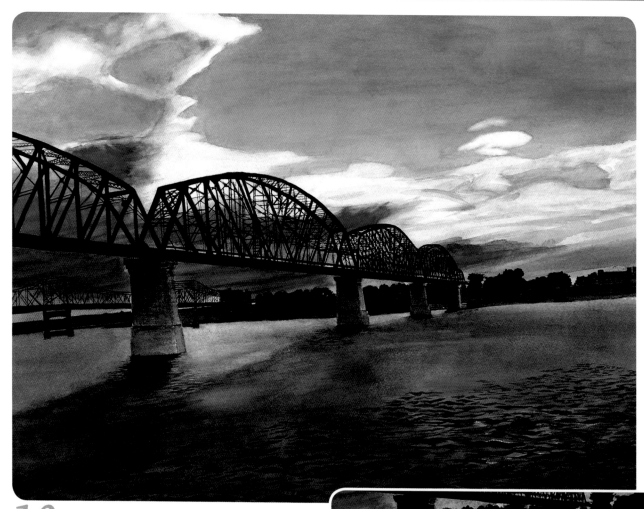

10 ADD THE RIVER'S DETAILS

Add another wash layer of the same mix from step 9. While the wash is still a bit damp, lay in streaks of a darker blue with a no. 4 or no. 6 sable round to indicate the larger waves that break across the surface of the water. The dampness of the paper will tend to soften their edges. Let the paper completely dry; then paint in the smaller waves. To achieve a sense of perspective, make the waves larger near the bottom of the painting and smaller and less distinct as they move back in the space.

Start scratching out some highlights on the river with a no. 616 craft knife blade, being careful to scratch on the completely dried paper surface. If the paper is still just slightly damp, it will shred and pull apart. Pull the blade carefully across the surface of the paper, never letting it tear through. Practice using the blade before actually applying its use.

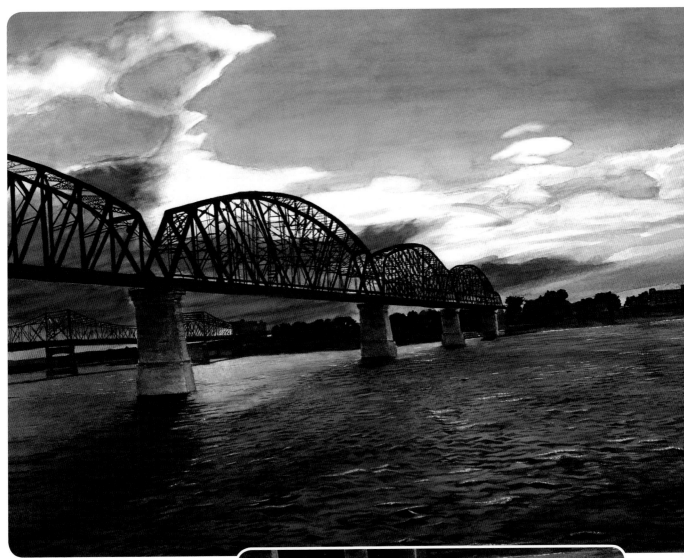

11 DEVELOP HIGHLIGHTS AND COMPLETE

All that remains now is the addition of more wave strokes and to continue adding highlights as you've been doing in step 9. Make the highlights fewer as you move toward the top of the river close to the shore.

LOUISVILLE'S OHIO
watercolor on 300-lb. (640gsm) cold-pressed paper
16" × 21" (41cm × 53cm)

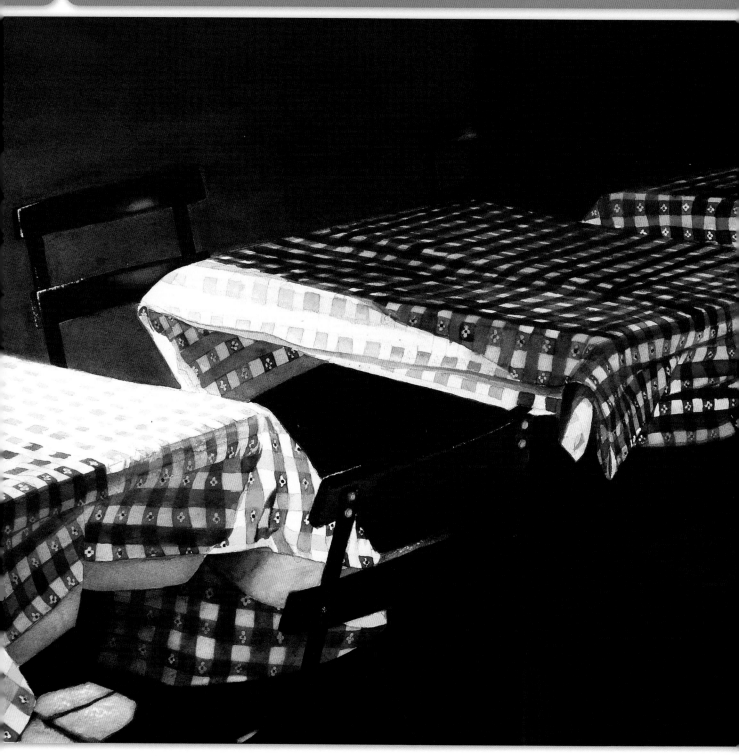

RENDEZVOUS PLACE
watercolor on 300-lb. (640gsm) cold-pressed paper
16" × 24" (41cm × 61cm)

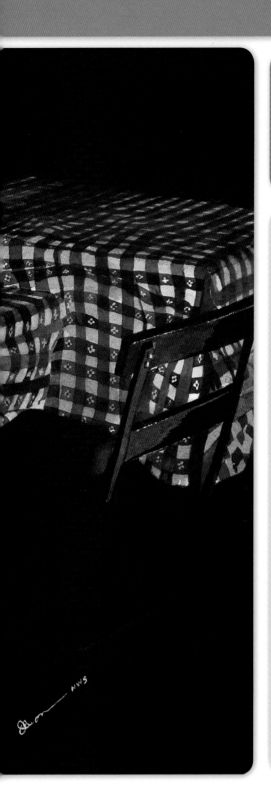

THINGS

When painting things I'm a nontraditionalist—I don't like to paint contrived still-life setups. I like to photograph and paint things as they are without having to move them around. For instance, I may be inspired by a group of tables and chairs, a pile of empty cans or an old tractor in a field.

The challenge with painting these things is to find interesting compositions that are readymade. Then all you have to do is photograph your subject at the right angle and in the right lighting. Just keep your camera with you at all times and be on the lookout for your dynamic subject—be it a simple orange or an old, rusted piece of machinery.

CHAIRS AND TABLES

MATERIALS LIST

SURFACE
300-lb. (640gsm) cold-pressed paper

BRUSHES
Nos. 4 and 6 sable rounds

PIGMENTS
Alizarin Crimson

Burnt Sienna

Burnt Umber

Cerulean Blue

Cobalt Blue

French Ultramarine

Ivory Black

Payne's Gray

Permanent Rose

Raw Sienna

Winsor Violet

OTHER SUPPLIES
3B pencil

Craft knife with no. 616 blade

Painting shadows from photographs is much easier than on location, as your shadows won't move and you'll have time to develop their patterns into your painting. Shadow patterns add much interest to a painting and help lead the eye around your subject. Shadows also help ground your subject, tying an object to whatever it is standing on so it doesn't appear as if it's floating in space.

REFERENCE PHOTO
The shadows on the floor in this café set up an array of interesting patterns because of the chair and table legs.

1 DRAW THE PATTERNS
Begin with a clearly defined pencil drawing. Define the shapes of the tables and chairs and trace the placement of the shadows using a 3B pencil.

2 PREP THE TABLES

Paint the tables with a pale mix of French Ultramarine, Cobalt Blue and Permanent Rose using a no. 6 sable round.

3 APPLY INITIAL WASHES ON THE CHAIRS

Wash a pale mix of Raw Sienna and Burnt Umber and paint the chairs with a no. 6 sable round. Allow this to dry and apply a second wash over the same area. You can start adding a small amount of color detailing on the chairs now as well.

4 ADD DETAIL TO THE TABLES

Darken the initial mix for the tables by adding Cerulean Blue, more French Ultramarine and a small amount of Payne's Gray with your no. 4 sable round. Paint in the tabletops, center supports and feet, making the tabletop darker than the rest of the table except the shadow side of the support.

Don't be too concerned about the reflections on the tabletops at this point.

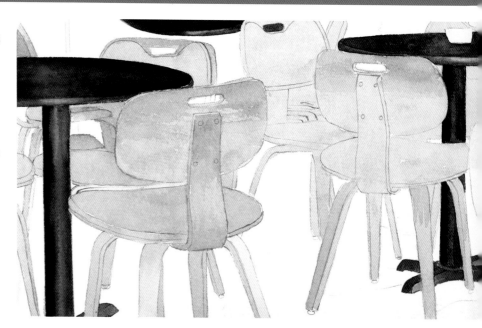

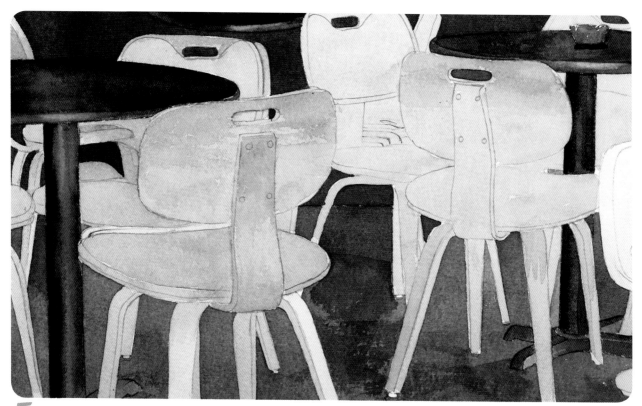

5 PAINT THE BACKGROUND AND FLOOR

Use the no. 4 sable round with a mix of Payne's Gray, Ivory Black and Permanent Rose to paint in the background around the top half of the tables and chairs. Use a mix of Alizarin Crimson, Payne's Gray and Burnt Sienna to layer in the floor area around the chair legs and tables.

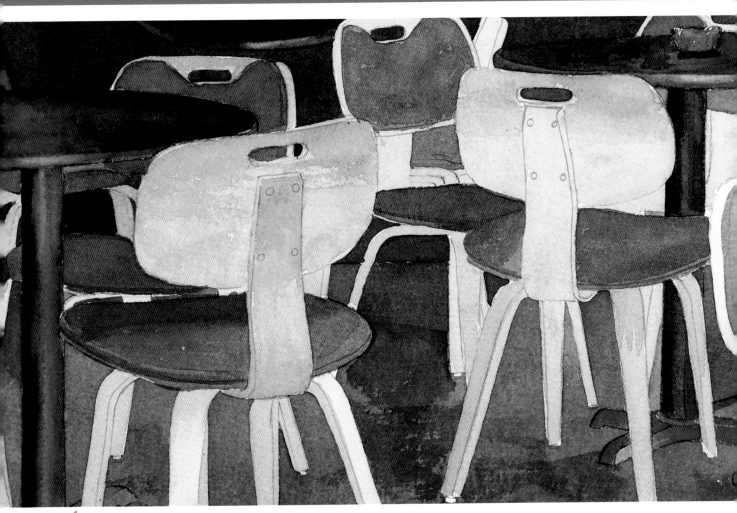

6 CONTINUE WITH THE CHAIRS

Darken the seats and back cushions of the chairs, using a no. 4 sable round and a mix of Burnt Sienna and Raw Sienna, and a small amount of Winsor Violet and Ivory Black. Let dry and apply a second wash of the same color.

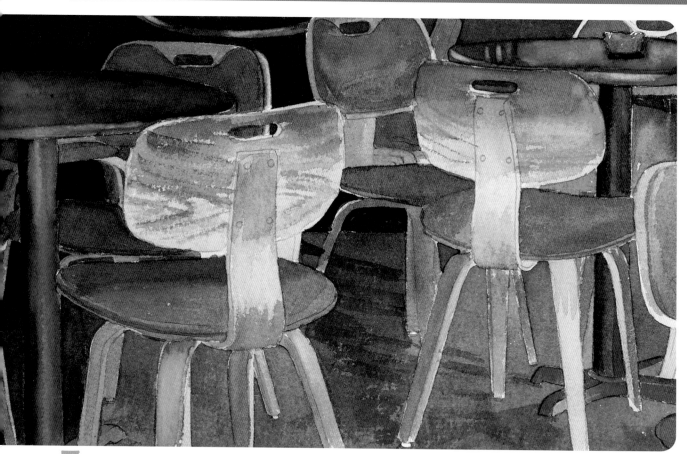

7 ADD DETAILS

By strengthening the wash for the chairs, you begin to add depth and more definition to the chairs. Using a medium-value wash of Winsor Violet, add a layer to the chair back cushions and the seat cushions using a no. 4 sable round. With the addition of Ivory Black applied to the seat cushions, you can start to add the shadows to the seats. Add streaks of Winsor Violet to the chair backs with a no. 6 sable round. Apply a medium-dark mix of Cobalt Blue, Burnt Sienna and Permanent Rose to the floor area to darken. Let this dry and then add the shadows from the chair legs and table supports with another layer of this same mix.

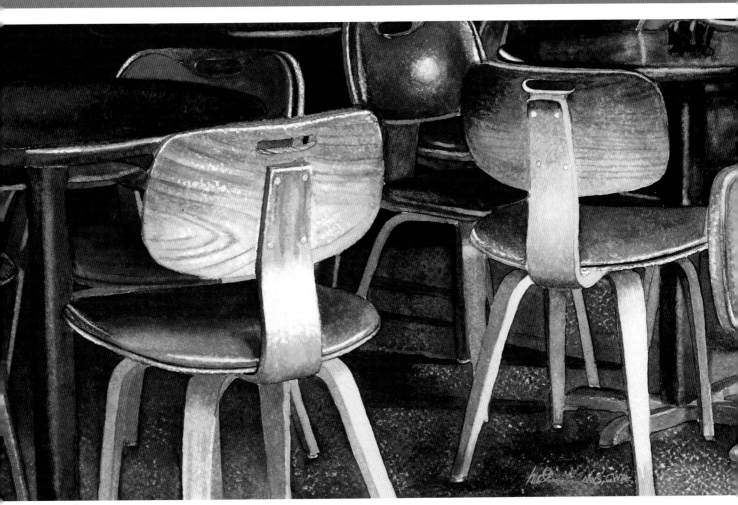

8 REFINE AND FINISH

Now it's time to wrap up the painting by refining the details in the background, foreground, floor area, tables and chairs. For the background, use a darker version of Payne's Gray and paint carefully around the tables and chairs.

Refine the tables with a darker version of the mixture in step 2. Some areas of the tabletop almost appear black; apply an Ivory Black wash to those areas and soften the edges. Then, using a craft knife, gently scrape the edge of each table where the highlights appear and soften those edges. Use a no. 6 sable round to lift out the subtle vertical highlights on the table support poles. The tabletop on the right of the picture shows a reflection. Use a no. 4 sable round to lift out the color until most of the white of the paper can be seen. With the same mixture used for the chairs, paint in the reflected color on the tabletops.

For the wood grain on the rear of the two chairs, apply a medium-value wash of Winsor Violet with a no. 6 sable round, using the tip to add in the grain texture. Let this dry and then soften the edges

For the floor, add another wash of the same floor mix used in step 5. Let this dry and apply a darker than medium value of Payne's Gray paint to represent the shadows from the chair legs and table support pole.

RIVER MARKET CAFÉ
watercolor on 300-lb. (640gsm) cold-pressed paper
8" × 14" (20cm × 36cm)

APPLES IN A BARREL

MATERIALS LIST

SURFACE
300-lb. (640gsm) cold-pressed paper

BRUSHES
Nos. 6 and 8 sable rounds

No. 6 synthetic round

PIGMENTS
Alizarin Crimson

Burnt Sienna

Burnt Umber

Cadmium Red

Cadmium Yellow

Cobalt Blue

Ivory Black

Olive Green

Payne's Gray

Raw Sienna

Viridian

Yellow Ochre

OTHER SUPPLIES
3B or 4B pencil

Craft knife with no. 616 blade

Masking fluid

Just as your own mood influences the way in which you see a subject, some subjects change their mood and character based on the way they are lit. Lighting plays an important part in creating a mood and particular atmosphere, which can trigger a powerful response in you. In this demonstration you will create a mood in a still-life setup with artificial light. While artificial light is more controlled than natural light, taking a photo of your subject in artificial light allows time to study and find the best angle in which to portray your subject.

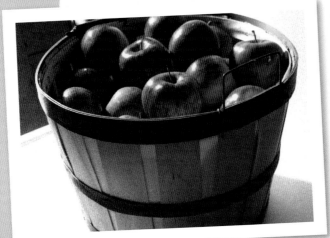

REFERENCE PHOTO
In the photo with the bushel of apples, the mood of the artificial light source seems to evoke a response of delicious-looking or appealing-to-the-eye fruit.

Even artificial light has its place in initiating responses.

1 START AT THE BEGINNING
Use a 3B or 4B pencil to complete a drawing of the still life, placing the highlights accurately. When highlights are in rounded forms like on these apples, their shape is vitally important.

You will eventually lighten these lines and they will be absorbed into the painting.

2 APPLY MASKING FLUID
Use a no. 6 synthetic round to mask the highlights on the apples in the bushel basket.

3 LAY THE FIRST WASH
Wash a pale mix of Cadmium Red and Cadmium Yellow over the entire apple area. Overlap the edges of the apples. Let dry completely. Then, apply a medium-value wash of Olive Green to the apples at the bottom right of the pile. Use a no. 8 sable round for this step.

4 ADD ANOTHER WASH
Mix Cadmium Red and Alizarin Crimson and use a no. 6 sable round to paint the apples in strategic areas, achieving local color and form. Notice how the area of the Olive Green wash you laid in step 3 now represents reflected light and gives the pile of apples depth.

5 DEVELOP DEPTH ON THE APPLES
To add a deeper red to the apples in order to show more depth, apply a mix of Cadmium Red, Alizarin Crimson, Burnt Umber and Ivory Black to the apples using a no. 6 sable round. Let dry, then add a darker version of this mix to the shaded side of the apples.

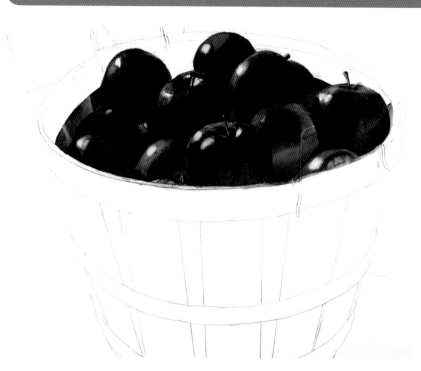

6 ADD FINISHING TOUCHES TO THE APPLES

Darken the original apple mix and continue to develop the apples' forms, adding Burnt Sienna to further darken the areas in the shadows. Refine the apple highlights by softening the edges with a no. 6 sable round and let dry. Use a craft knife to gently scrape the center of the highlights to bring out the white of the paper surface.

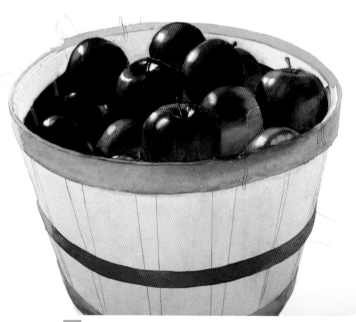

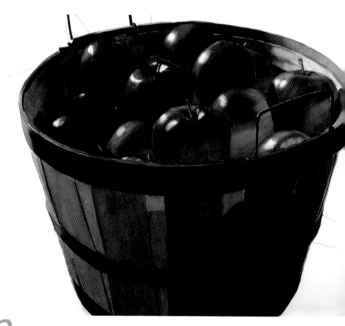

7 PREPARE THE BUSHEL BASKET

Add the initial wash to the basket with a medium-value mix of Cadmium Red, Yellow Ochre, Raw Sienna and a small amount of Payne's Gray. Wash this over the entire surface of the basket with a no. 8 sable round, including the three rings of the basket, and allow to dry. For the green rings, apply a medium-value mix of Viridian, Olive Green and Cobalt Blue. For the red ring, apply a medium-value blend of Cadmium Red and Alizarin Crimson.

8 FINISH THE BUSHEL BASKET

Finishing the basket is just a matter of darkening the colors for the green and red bands and the color for the vertical slats with additional layers of the original colors. Then, add the shadows with the addition of Ivory Black to those mixtures. Add Alizarin Crimson to the mix for the red reflection of the apples on the basket. With a damp no. 6 sable round, lift out the color in the top portion of the basket, just below the top green rim, to show light filtering through the wooden slats.

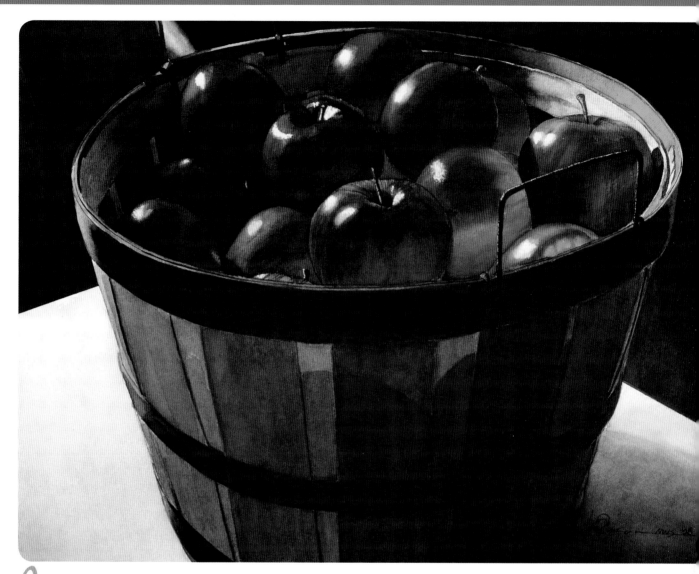

9 COMPLETE THE BACKGROUND

Adding the background establishes the subjects within a specific space relationship. Paint the brown boards in front of the basket with a mixture of Burnt Umber, Alizarin Crimson and Payne's Gray. Notice the addition of the dark wall that is not present in the resource photo. This will further establish a mood and helps show off the strong light source that's penetrating the basket. Also, because the light source is suggested and not shown, the mood suggests an air of mystery.

AN APPLE A DAY
watercolor on 300-lb. (640gsm) cold-pressed paper
13" × 17" (33cm × 43cm)

FRUIT, GLASS, TUREEN AND LACE

MATERIALS LIST

SURFACE
300-lb. (640gsm) cold-pressed paper

BRUSHES
Nos. 1, 4, 6 sable rounds

PIGMENTS
Alizarin Crimson

Burnt Umber

Cadmium Red

Cadmium Yellow

Cerulean Blue

French Ultramarine

Ivory Black

Olive Green

Payne's Gray

Permanent Sap Green

Raw Sienna

Winsor Yellow

Yellow Ochre

OTHER SUPPLIES
3B pencil

Craft knife with no. 616 blade

Unlike landscapes and figures, still lifes can be completely controlled by the artist. Choose still-life objects for their visual interest and personal meaning for the artist. Setups can be simple or complex, and can include traditional objects such as fruit or flowers, something as simple as a glass or something that has significant meaning, such as a certain bowl. Using your camera also opens up many avenues to portray your still life such as lighting, composition and angle of approach.

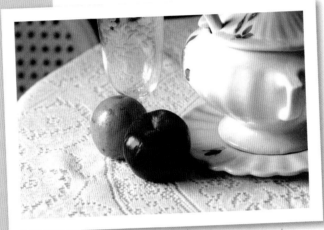

REFERENCE PHOTO
The light in this photo comes from natural midday light streaming through the dining room window. I liked the way it washed over this subject and brought out the textures of the objects in the composition.

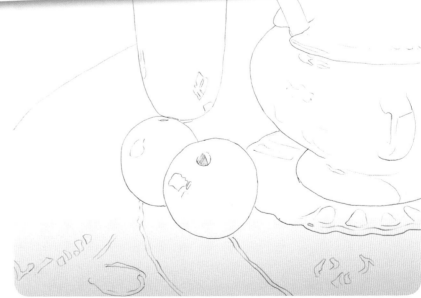

1 THE BEGINNING
Transfer the photo to your paper with a 3B pencil.

2 START PAINTING THE ORANGE

Start the orange with a pale mix of Cadmium Yellow, Winsor Yellow and a small amount of Permanent Sap Green using a no. 6 sable round. Leave the area intended for the highlight unpainted.

3 CONTINUE PAINTING THE FRUIT

Apply a mix of Cadmium Red, Alizarin Crimson and Cadmium Yellow on the apple using a no. 6 sable round. Let it dry and then apply a darker layer by adding French Ultramarine and Payne's Gray until you get the value you are satisfied with.

Mix Burnt Umber and Payne's Gray for the shadow on the right side of the orange.

4 FINISH THE FRUIT

Still using the same brush, paint a stronger version of Cadmium Yellow, Winsor Yellow and a small amount of Cadmium Red on the orange to reveal the bumpy surface of the peel.

Mix a darker version of the apple color in step 3 and apply to the apple. Paint carefully around the highlights. Use a damp no. 6 sable round to gently drag a small amount of the apple color across the highlight area until it is a very pale red. Let dry. Lightly drag the side of the craft knife blade across the highlighted area until some of the paper surface starts to show through.

5 PAINT THE GLASS AND BOWL

Use a no. 4 sable round to paint the stemware with a pale mix of Cerulean Blue and Permanent Sap Green to show the basic form. For the bowl, apply a pale mix of Yellow Ochre, Cerulean Blue, Cadmium Yellow and Olive Green with a no. 4 sable round to show the form and contours.

6 FINISH THE DETAILS

Use a no. 4 sable round to finish the details of the bowl and glass, strengthening the mixtures from step 5 and gradually adding layers to bring the details to a finish. Let this dry.

For the apple's shadow, use a no. 6 sable round with a very dark mix of Alizarin Crimson, Permanent Sap Green and French Ultramarine. While the shadow is still wet, rinse your brush and blend the bottom edges of the shadow down to a very pale value.

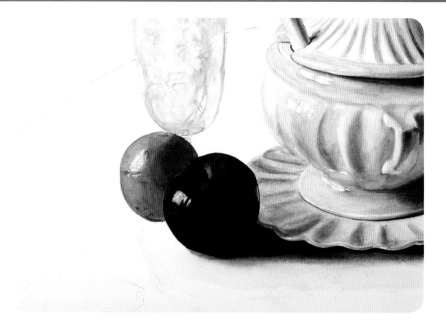

7 DEVELOP THE BOWL, GLASS, LACE TABLECLOTH AND BACKGROUND

Refine the contours, shadows and highlights on the bowl with additional layers of the mix from step 5. Once dry, add in highlights with a craft knife, lightly scraping away the wash with the side of the blade using angular strokes.

For the glass, use the Cerulean Blue and Permanent Sap Green mixture with a no. 4 sable round to apply an overall wash and let dry.

With a very pale mixture of Raw Sienna, Alizarin Crimson and a small amount of Cerulean Blue, apply an overall wash with a no. 4 sable round to the tablecloth area. Let dry and apply a second wash of the same mixture. Darken the same tablecloth mixture with Payne's Gray to a medium value and use a no. 1 sable round to paint in the lace details (the holes in the tablecloth). Apply an Ivory Black wash in the background area.

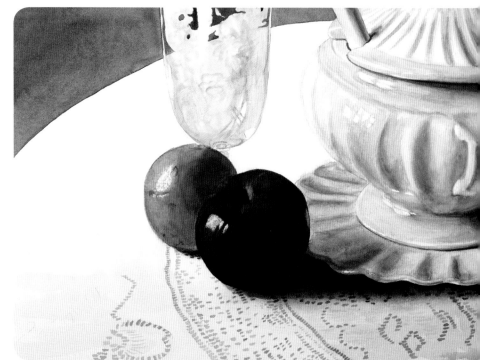

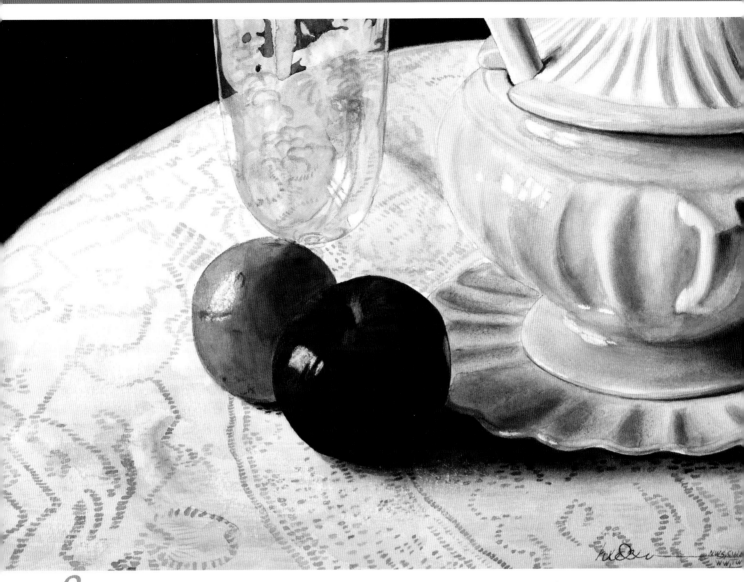

8 KEEP BUILDING AND FINISH THE DETAILS

Continue to develop the bowl and glass as needed to finish the form using the same mixes as previous steps, letting the paint dry and using the craft knife for additional highlights you may have missed. For the tablecloth, continue to paint in the details using the mix from step 7.

THE TABLE SET
watercolor on 300-lb. (640gsm) cold-pressed paper
11" × 16" (28cm × 41cm)

Setting Up Your Own Still Life

Still-life subjects are basically inanimate objects. In other words, there is no life, as we see life, in them. They won't move around out of place when you set them up and/or photograph them. Still-life objects should be chosen for their visual interest and their meaning to the artist.

Setups can be simple or daunting tasks and can include traditional objects such as fruit or flowers, or less common items such as a crumpled tin can or garden tools.

Whatever you choose to portray, the variety and arrangement of the objects should be interesting to you and should stimulate you to paint or draw with enthusiasm. Pay special attention to the background for the objects. Their environment is often as important as the objects themselves.

FOUNTAIN AT NIGHT OR DUSK

MATERIALS

SURFACE
300-lb. (640gsm) cold-pressed paper

BRUSHES
Nos. 4, 6, 8, 10 sable rounds

No. 4 synthetic round

PIGMENTS
Burnt Sienna

Cadmium Red

Cadmium Yellow

Cerulean Blue

Cobalt Blue

French Ultramarine

Ivory Black

Payne's Gray

Permanent Rose

OTHER SUPPLIES
2B pencil

Craft knife with no. 616 blade

Masking fluid

Rubber cement pickup

Still lifes do not have to be indoor subject matter. Although the term conjures up images of bowls of fruit, bottles and vases of flowers on a table, outdoor groups or even a single subject offer equally exciting possibilities. Tables and chairs in a restaurant setting, an old rusty cultivator in a overgrown field or a piece of garden statuary could form the basis for an exciting painting. When you come across a scene at night or in changing light, it is best to take photos so you can capture its mood and drama.

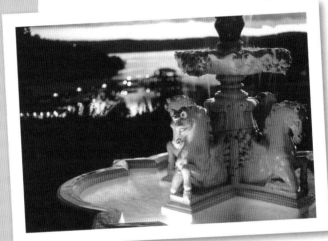

REFERENCE PHOTO
This old fountain really captured my attention in the daylight, but at nightfall it excited me and raised the hairs on the back of my neck. It was unbelievable. I definitely had to paint it.

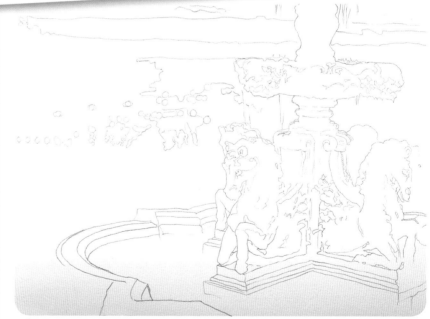

1 DRAW THE FOUNDATION
Use a 2B pencil to draw the basic foundation line drawing. This drawing should establish the major color areas of the painting.

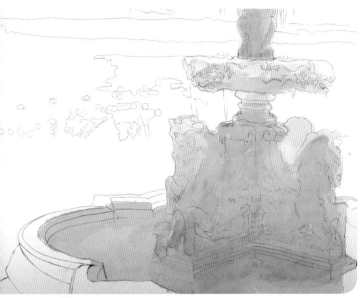

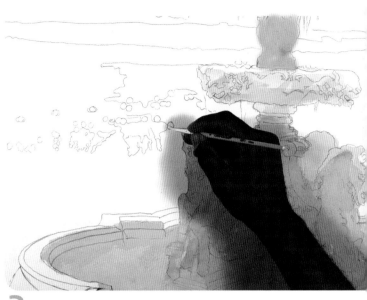

2 LAY THE FIRST WASH

Wash a mix of Cadmium Red and Cadmium Yellow onto the main part of the fountain with a no. 10 sable round. This wash establishes the color. All the detail will come later in the painting.

3 APPLY MASKING FLUID

Use a no. 4 synthetic round to apply masking fluid to the areas that will represent lights in the night around the lake and marina. The masking fluid will preserve the paper for when it is time to finish the final details.

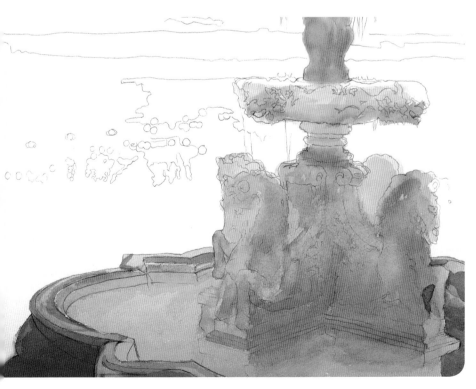

4 START THE FOUNTAIN BASE

Paint a mix of French Ultramarine and Payne's Gray onto the base with a no. 6 sable round. Do not be concerned with the details of the base at this point.

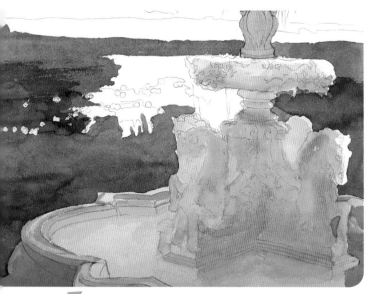

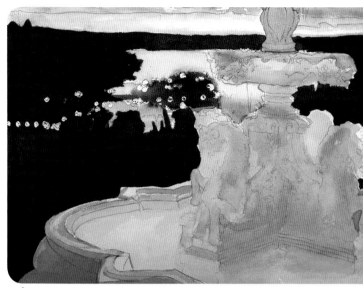

5 ADD THE BACKGROUND AND HORIZON

The horizon forms a silhouette against the light of the setting sun. The ground area surrounding the lake links to the horizon. Paint both the horizon backdrop and the land areas with a darker than medium range value mix of Ivory Black and Payne's Gray using a no. 10 sable round. Let dry.

6 DEVELOP THE BACKGROUND AND SKY

Use a no. 6 sable round to add a second application of the Ivory Black and Payne's Gray mix to the background, and a mix of Cobalt Blue and Cerulean Blue to the cloud area of the sky. Then mix Permanent Rose with water and apply to the sky area directly beneath the clouds using the same brush. Next, add the Permanent Rose and the blue sky mixture to the lake area in the background with a no. 8 sable round to represent the reflection of the sky.

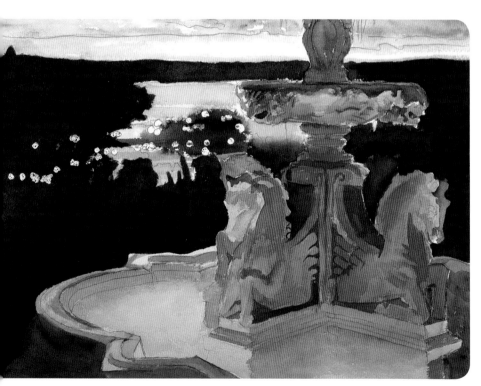

7 DETAIL THE FOUNTAIN

Strengthen the orange mixture from step 2 and add Burnt Sienna and a small amount of Ivory Black to get a deep brownish orange. Use a no. 6 sable round to apply this over the shaded areas, drawing in the winged horses and the fountain cap with the lions' heads with your paint. Watch the depth of the painting begin to unfold.

Strengthen the Cerulean Blue mixture and use the same brush to paint the top of the fountain cap on either side to represent the dark water. Darken the pole on top of the fountain cap as it is hidden from the lights within the fountain.

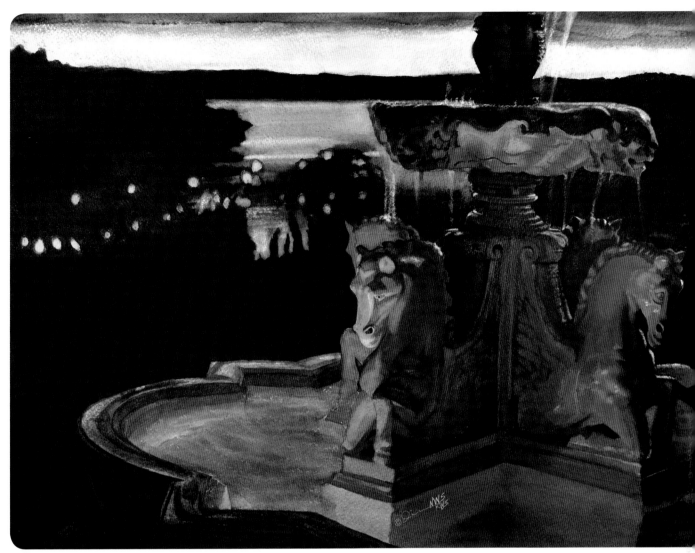

8 FINALIZE THE PAINTING

Darken the blue at the top of the cap where the water is spilling over with an additional layer of the same mix from step 7. Then use a damp no. 6 sable round to lift out the water spilling and splashing through the clouds and horizon.

Remove the masking fluid with a rubber cement pickup and paint in the orange lights in the background and around the marina area with a no. 4 sable round. Make the entire background area much darker and soften the edges using additional layers of the previous mixes.

Darken the clouds with a darker version of the Cerulean Blue and the Cobalt Blue mix from step 6 and lift out color to represent clouds.

Add in the shadows of the four winged horses with a no. 4 sable round and strengthen the main orange hue using a mix of Cadmium Red, Permanent Rose, Cadmium Yellow and Ivory Black. Notice the placement of the shadows on the horses. They appear on the tops of all the forms because the horses are lit from below.

Further darken the blue on the top edge of the fountain's base with a no. 4 sable round and strategically lift out color to represent the reflection of the sky. Also lift out color from the inside of the base to show that there is water there. Remember to soften the edges of the lights out in the lake area and around the marina. The edges should be very soft.

Gently scrape out color with a craft knife to portray the water dripping and splashing from the fountain, and along the top of the horses as highlights.

NIGHT VISION 4—TABLEROCK LAKE
watercolor on 300-lb. (640gsm) cold-pressed paper
18" × 24" (46cm × 61cm)

METAL BENCH WITH LUNCH BAG

MATERIALS

SURFACE
300-lb. (640gsm) cold-pressed paper

BRUSHES
Nos. 4 and 10 sable rounds

PIGMENTS
Alizarin Crimson

Burnt Sienna

Cerulean Blue

Cobalt Blue

Ivory Black

Payne's Gray

Raw Sienna

Winsor Green (Blue Shade)

Yellow Ochre

OTHER SUPPLIES
3B pencil

220-grit sandpaper

Most still lifes have a theme associated with them, relating the objects to one another through a common purpose. When I saw this bench with the empty lunch bag and coffee cup in this little out-of-the-way cove, I immediately thought of someone on a lunch break in privacy. Someone who thought, "Today I don't want to be bothered. I just want to be able to eat my lunch and contemplate without any chatter." Still lifes can be captured in the most intimate or the most lively of places. Keep your camera with you and seize the moments and opportunities.

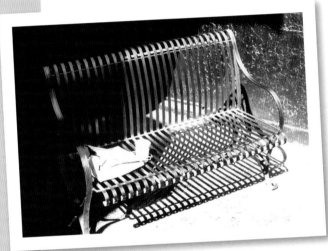

REFERENCE PHOTO
While on a trip, I decided to just walk around with camera in hand. I literally stumbled upon this little cove area with the metal bench, empty lunch bag and coffee cup and immediately snapped several pictures.

1 COMPLETE A DRAWING
To ensure an accurate depiction of the bench within the painting, complete a detailed pencil drawing in order to indicate all the lines and angles within the composition, including the paper bag and paper cup on the bench.

2 LAY WASHES ON THE BENCH

It is best to gradually bring along the bench. Paint the blue reflection of the sky on the top part of the bench slats with a midrange value of Cerulean Blue using a no. 4 sable round. Don't be too concerned about staying exactly within the pencil lines of the metal slats as the dark background will eventually cover up any overpainted areas. Next, mix a slightly darker than midrange Ivory Black and apply to the back slats and seat slats.

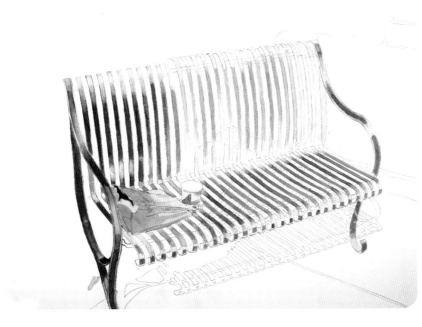

3 REFINE THE BENCH AND START THE BAG

Continue to add depth and detail to the bench by darkening the blue and gray of the bench slats or bars and adding the line detail to the armrests with a no. 4 sable round. Begin adding color to the bag and cup with the same brush by mixing Yellow Ochre and Raw Sienna for the bag. Use Cobalt Blue and Alizarin Crimson for the designs on the cup.

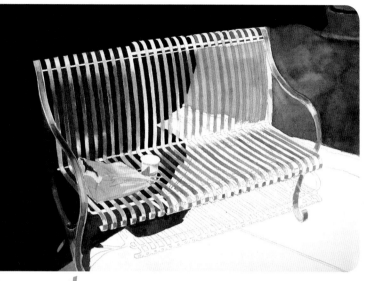

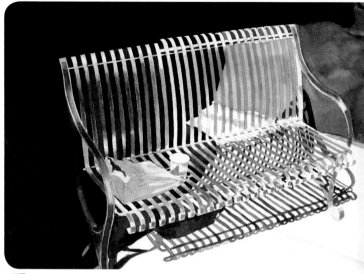

4 PAINT IN THE BACKGROUND

To further give the bench some depth, or to add depth to the composition, paint in the background using a no. 10 sable round with a mix of Payne's Gray, Alizarin Crimson and Winsor Green. This mixture will give the background a cooler temperature against the bench, and will enhance the warmth of the lunch bag. Use a slightly darker than midrange value for the initial application. Apply and let dry. When completely dry, apply a second wash, let dry and apply a third wash if necessary. Be careful when painting around the metal slats of the bench to keep edges straight and crisp.

5 ROUGH IN THE SHADOWS

Add the shadows of the metal bench using a no. 4 sable round with the same mixture as the background, but at half strength. Let dry.

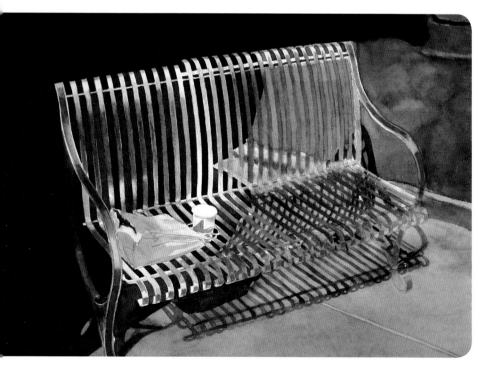

6 LAY IN THE GROUND AREA

For the ground area, add a small amount of Burnt Sienna to the shadow mix of step 5. Apply a first wash with a no. 10 sable round and allow to dry, then apply a second wash at half strength.

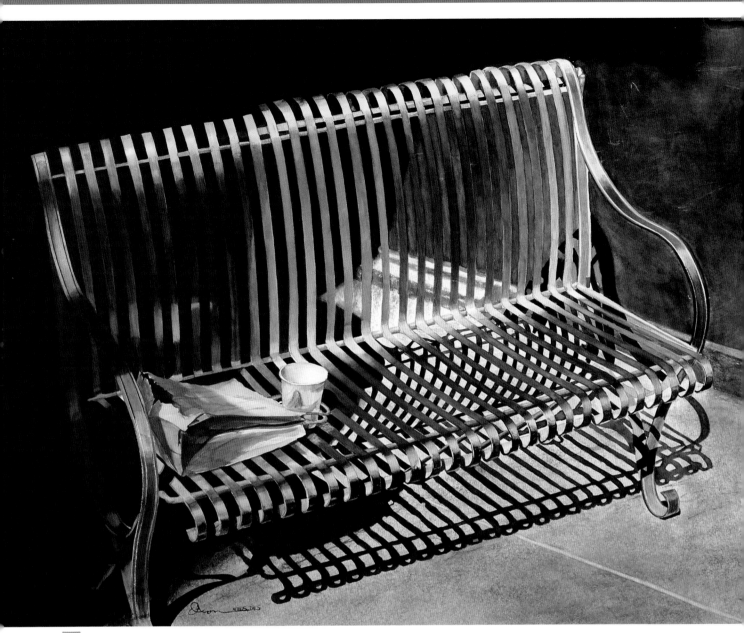

7 REFINE AND FINISH

To finish and refine the painting, dramatically darken the background shadow on the left half. While accomplishing this, you can render the metal slats of the bench with a much more defined edge. For the right side area of the background, darken with a darker than medium-range value of black or the same mix of Payne's Gray, Alizarin Crimson and Winsor Green. Add the finishing detail to the lunch bag and paper cup with the same mixes as in step 3. With a piece of 220-grit sandpaper, lightly rub the surface of the ground area to create the texture of concrete. Then darken the shadows of the bench on the ground area.

BIG APPLE HIDEAWAY
watercolor on 300-lb. (640gsm) cold-pressed paper
18" × 24" (46cm × 61cm)

CONCLUSION

When I take a photograph, I am not expecting to produce a masterpiece. But if the subjects and forms are interesting to me, I'm hoping for the possibility of a dynamic watercolor painting. It is not my intention to become a professional photographer looking for that awesome masterpiece. The camera happens to be one of my favorite *tools,* a means to an end. It is a means for me to capture my favorite subjects to later paint in my studio. Hopefully this book will reach out to those watercolor artists, beginning or professional, who are of a similar persuasion. Both my photographs and my watercolor paintings are the results of much perseverance.

Watercolor by itself is an ever-learning art experience, but the process of development can be enjoyable at any stage. In my early years of trying to enter juried exhibitions, being accepted was few and far between. But as I continued to paint, continued to search for examples of artists' who were winning top awards and being accepted into the world's top exhibitions, continued studying their work and reading their articles, I realized that with much work and even more perseverance I could do it also.

Eventually those opportunities came and I started reaching those same accomplishments. If you are a beginning watercolorist, find an established artist that you admire a great deal and use him or her as a mentor for your own improvements and accomplishments. You can have several mentors that will afford you the opportunity to tap into a pool of immense and diverse ideas.

Most professional accomplished artists will be more than happy to mentor you, the up-and-comer, but at the same time you must respect their time.

This book is written on the assumption that readers will be not only interested in technical savvy but also in mastering the art of watercolor. One of the beauties of watercolor painting is that it allows you to move ahead quickly. In a few weeks' time you can explore a full range of techniques and applications, thus discovering the medium's possibilities and preparing yourself for the more important task of developing a personal self-fulfillment.

After you have explored the examples and steps in this book, what you decide to do with watercolor is of great concern to me as a watercolorist. Unfortunately, we can't meet and sit down together for a personal one-on-one discussion of your paintings, but perhaps some general advice would be helpful.

First, keep in mind that painting is a way of expressing yourself, and that expression is by way of a personal watercolor style—finding a subject and technique that are compatible with that style.

Second, one thing you will need, if you are to work independently, is a way of keeping your spirits up. One of the things that helped me was getting a number of paintings framed and working with local libraries to exhibit my work there. There is no better feeling than having a few selected watercolors proudly displayed for everyone to admire.

Finally, I urge you to consider entering your work in national juried exhibitions. You may not be ready to take this step for a while, but it is something to aim for, because showing your work, in a sense, completes the creative experience.

I hope you, the beginning watercolor artist, will avail yourself of these opportunities, and that the advice and information conveyed in this book will contribute in some small measure to your success.

LOUISVILLE'S OHIO
watercolor on 300-lb. (640gsm) cold-pressed paper
16" × 21" (41cm × 53cm)

INDEX